ALBUQUERQUE BEER

Duke City History on Tap

CHRIS JACKSON

AMERICAN PALATE

Chamblin Bookmine
Chamblin's Uptown
Jacksonville Florida

Published by American Palate
A Division of The History Press
Charleston, SC
www.historypress.net

Front cover image, "Large Evening Sky," from Free ABQ Images.

First published 2017

Manufactured in the United States

ISBN 9781625858498

Library of Congress Control Number: 2017931800

Contents

Preface 5
Prologue 7

The Beginning 11
The Wild West, 1988–1995 18
The Second Wave, from Boom to Bust, 1996–2000 27
New Century, Same Problems, 2000–2008 40
The Rising, 2008–Present 53
Booming in the Burbs 87
Hauling Medals and Firing Up Competition 100
Of Brewers, Brewers Guilds, Beer Geeks and Beer Fests 109
The Future 118

Selected Bibliography 123
Index 125
About the Author 128

Preface

J ust about any history book, even on a subject such as craft beer, requires
a group effort to complete. I have many people to thank for their help
with this book, first and foremost being my acquisitions editor at The
History Press, Candice Lawrence. Her patience alone was a tremendous
help in my first writing endeavor of this nature.

Retired brewers Mike Carver of Cabezon Brewing and Brad Kraus of Rio
Bravo Restaurant Brewery deserve special thanks, as they were gracious enough
to take the time to sit down and talk about their experiences in the 1990s.

There are so many people to thank from the list of active breweries,
including those who sat down for extended interviews about the scene: Mike
Campbell of Drafty Kilt/Cazuela's/Tractor, Doug Cochran of Canteen/Il
Vicino/Kellys, John Gozigian of the NM Brewers Guild/Marble/Chama
River/Blue Corn, Daniel Jaramillo of La Cumbre/Marble/Blue Corn/
Assets/Bavarian Lager Cellar/Rio Bravo, Mark Matheson of Kaktus/Turtle
Mountain/Assets, Brady McKeown of Quarter Celtic/Canteen/Il Vicino,
Nico Ortiz of Turtle Mountain, Ted Rice of Marble/Chama River/Blue
Corn and Rich Weber of Sierra Blanca.

Beyond them, a big thanks to all the folks who have been willing to sit
down for multiple interviews with the Dark Side Brew Crew over the years,
including James Warren of Santa Fe Dining/Blue Corn; John Bullard,
Gabe Jensen, Jotham Michnovicz and Tim Woodward of Bosque; Kevin
Davis, Justin Hamilton and David Kim of Boxing Bear; Matt Simonds of
Broken Trail; Zach Guilmette of Canteen; Andrew Krosche of Chama

River; Angelo Orona of Craft King Consulting; Todd Yocham of Duel; Dana Koller and Michael Waddy of Kaktus; Jeff Erway of La Cumbre; Leah Black, Barbie Gonzalez, Anna Kornke and Josh Trujillo of Marble; Ken Carson and Kaylynn McKnight of Nexus; David Facey and Ror McKeown of Quarter Celtic; Matt Biggs, Jeff Hart, Wayne Martinez and Rob Stroud of Red Door; Ty Levis and John Seabrooks of Rio Bravo; Bert Boyce, Alana Jones, Brian Lock, Monica Mondragon and Silas Sims of Santa Fe; Rod Tweet of Second Street; Dan Herr of Sidetrack; John Starr and Rob Whitlock of Starr Brothers; Josh Campbell, Carlos Contreras, Skye Devore, Nicole Duke, David Hargis, Jeremy Kinter, Melissa Martinez and Lauren Poole of Tractor; and Mick Hahn of Turtle Mountain, plus many, many more.

Additionally, there were many folks who helped, in big ways and small, with the completion of this book, from gathering images to offering up little pieces of advice and information along the way, including the photographer-extraordinaire duo of Mario Caldwell and John Campi, plus Adam Galarneau, Stan Hieronymus and Jon Stott.

Of course, I never would have even been considered for writing this book were it not for the friends with whom I started the NM Dark Side Brew Crew back in 2012. To Derek Bensonhaver, Jon Kidd, Franz Sturm, Erik Teixeira and Brandon Trujillo, you all deserve a lot of credit for this book's existence as well. The website has since added many great writers and friends, including Adam Auden, Kristin Elliott, Luke Macias, Reid Rivenburgh and more. I should also add that the website was inspired by the work of Patrick Cavanaugh, the original ABQ Beer Geek, who continues to be one of many passionate beer lovers who are the lifeblood of our little community.

A final set of thank-yous goes to my parents, David and Joanne Jackson, who have put up with all this writing nonsense, and sometimes even encouraged it, for many years. Also, thank you to just a few of the key people who have helped me keep writing over the years, including Todd Bailey, Craig Degel, Paige Galvin, Randy Harrison, Jim Johnson, Mike Robertson and Mark Woodhams.

Finally, to my late friend Vince Malesich, who died in 1995 and told me way back then that I would definitely write a book someday, thank you. I am glad you were right.

Prologue

Dude, what's on tap?

It was this question, or something similar, that basically launched my career as a beer writer. I had been a sportswriter since graduating from college, at least until the newspaper industry endured a yearlong implosion in 2008. After moving back to my hometown of Albuquerque from Southern California at the end of the year, I found myself drifting in life and in career.

I had already become a craft beer fan from my time in the Los Angeles area, but back then, all I knew about beer in New Mexico was from places like Chama River and Turtle Mountain in Rio Rancho, brewpubs where one could get a bite to eat along with a pour of stout or red ale. Santa Fe and Sierra Blanca beers could be found in six-packs around town.

Then I visited a downtown dive bar, Burt's Tiki Lounge, to watch local music, noticing two unusual tap handles. They were solid white with colored marble-like balls at the top, one red and the other green. The bartender said they were from the aptly named Marble Brewery, which had just opened a few months earlier a few blocks north of downtown.

By 2011, the dive bars and music clubs were no longer the primary hangouts for me and my friends. Instead, we had migrated to the many brewery taprooms popping up around town. When our friend Franz announced that he was getting married in September, a group of friends called on me, of all people, to plan out his bachelor party. Rather than an old-fashioned pub crawl, we elected to do a brewery crawl. It required a designated driver and an oversized vehicle, but in the end, I was able

to map out a plan to hit eight of the nine breweries in the metro area at that time.

We started at Turtle Mountain and then went to Hallenbrick, Nexus, Il Vicino Canteen, La Cumbre and Marble. By that point, the groom-to-be was past the point of coherence, and others were in even worse shape. We abandoned our plans to visit the Chama River Microbar and the Tractor Nob Hill Taproom.

A short time later, one of the group noted that if we had known in advance what specialty/seasonal beers were on tap, we might have skipped one of the places we visited and gone to one that we missed. Information on the available beers was scarce. Few of the breweries were taking advantage of social media the way they do now. Their individual websites were primitive at best, infrequently updated and usually just armed with information on their core or house beers, those available year-round. The local media, print, television and online sources ignored the burgeoning craft scene for the most part.

Rather than simply rue that gap of information, one of our group, Jon Kidd, made a simple suggestion: why don't we start our own beer news website? After a few months of procrastination following Franz's wedding in September, we decided to move forward at year's end. It would be a group effort, using our different palates and different perspectives to speak to the growing craft beer community. We would focus mainly on reporting what was going on rather than just offering up our opinions on things. All the site needed was a name.

On New Year's Eve, or what was by then technically New Year's Day, I was ruminating over a growler of Tractor's PTO Smoked Porter in a friend's backyard around a dying fire. Our group could just about agree on only two things: one, we all generally liked the darker beer styles such as porters and stouts; and two, we were all a bunch of metalheads. Staring into the night sky, I came up with "Dark Side Brew Crew" as a name for our motley collective and, potentially, the website. Jon agreed with the choice, and after we slapped an "NM" in front of it to designate our whereabouts, the website nmdarksidebrewcrew.com was launched on January 5, 2012.

Our handful of scattered stories early on were read by about twenty to twenty-five people apiece. They were mostly friends and family. None of us had any real idea of how to grow the site, other than to keep sharing its Facebook page with more and more people.

Over time, many of us had become known to the staffs at our local breweries and taprooms. One afternoon, I walked into Tractor Nob Hill

and was greeted by "beertender" Lauren Poole, who said that she had a story for us. A city official had casually informed Tractor that it was illegal to sell growlers of beer due to a long-forgotten Nob Hill ordinance. This came more than six months after the taproom had opened. After a little research, I translated the legalese of the Nob Hill Sector Redevelopment Plan and explained on our site what was happening. Tractor shared the story on its Facebook page, and overnight our audience increased tenfold.

Since then, the website has taken on a life of its own. It has surpassed 100,000 views annually. The Crew, with myself as editor based on my previous journalism experience, has visited and reported on almost every brewery in New Mexico. As most of us are based out of Albuquerque, we have been mainly focused here, reporting on the rapid and seemingly unstoppable growth of our local beer scene. We have interviewed the brewers and owners, broken news stories and generally done our best to shape how information flows from the breweries to the general public.

By 2016, I found myself as a credentialed reporter covering the Great American Beer Festival in Denver in October. I broke the news that Boxing Bear Brewing had earned the Mid-Size Brewpub of the Year Award after a clerical error had initially given the honor to another brewery.

Some time before, I was contacted by The History Press to follow up on Jon C. Stott's book, *New Mexico Beer*, with a new history book focusing solely on Albuquerque. This book is the result of months of research, interviews and a seemingly never-ending hunt for photographs, new and old. All of this has been born out of my love for craft beer, the community it has created, the jobs and other industries it supports and how it has shone a bright light on my beleaguered hometown, where good news has been hard to come by in recent years.

There were nine active breweries in the Albuquerque Metro Area in 2011. Just five years later, there are thirty-two, with two of them now producing more than ten thousand barrels per year and even distributing out of state. State records show that another six breweries have applied for small brewer licenses, all with the hope to open by the end of 2016 or some time in 2017—and rumors persist about another half-dozen beyond those.

Craft beer is booming in Albuquerque. It has come a long way since I started writing about it. It has come even further from its original roots in the nineteenth century.

The Beginning

Albuquerque is now the largest city in New Mexico, with its metropolitan population of 907,301 accounting for more than 40 percent of the state's entire population. It was not always this way.

When the railroad arrived in Albuquerque in 1880, the United States Census showed a total of just 2,315 residents. It was not a surprise, then, that the business of brewing beer commercially was slow to arrive in the Duke City.

Prior to the railroad, getting beer to Albuquerque, or anywhere in New Mexico, was impossible. Transporting beer by horse-drawn wagon was improbable at best, ludicrous at worst. Without any local supply of barley or hops growing in the state's arid climate, acquiring local ingredients was impossible as well.

The arrival of the railroad, at the very least, brought some of those ingredients to the small but growing town. The first brewing operations were likely similar to what people have today when home brewing—just a few pots and kettles to make beer in the back of the saloon or restaurant. Repurposed dairy equipment was typically used in the creation of beer, much of it by German immigrants who had flooded into the Midwest in prior decades, creating huge breweries that still exist to this day, such as Miller, Pabst and Anheuser-Busch.

Records show that there were at least two breweries in Albuquerque in 1882. No names were listed for these small establishments, which were a source of debate among town leaders concerning the growing saloon presence in the "New Town" area closer to the train tracks.

Brewing in Albuquerque never really began in earnest until the late 1880s. That was when Don J. Rankin and Harry Rankin arrived in town from Lawrence, Kansas. The duo founded the Southwestern Brewery and Ice Company in 1888. Located on the east side of the train tracks, at the modern address of 601 Commercial Northeast, just south of Lomas Boulevard, the nascent brewery sprang up out of a series of small buildings. An older brewery, in an adobe building, had existed at the same site until it burned down in 1887.

The Rankins hired Jacob and Henry Loeb, brewmasters from Germany by way of St. Louis, to begin producing typically German styles of lagers and bocks in 1889. They supplied a growing population of Anglos moving into the New Town area around the train tracks, located some two miles east of the Old Town, where families of Spanish descent were still predominant.

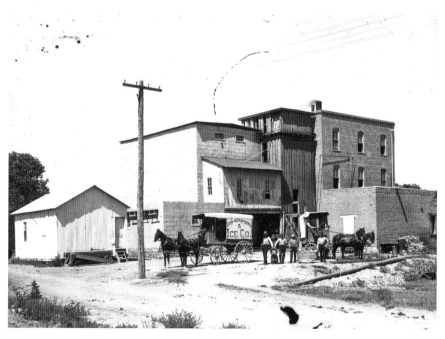

The Southwestern Brewery & Ice Company expanded significantly from its opening in 1888 through the next decade. *Courtesy of Albuquerque Museum.*

Within ten years, Southwestern was one of the largest employers in the town, with some thirty-plus workers operating out of the growing facility. The main brewery building stood five stories tall, making it the tallest building in town, easily visible from the surrounding neighborhoods and the nearby saloons. The fifth floor was an attic used for storage space. The other four floors were in use for the brewery itself.

Newspaper stories talk of the brewery's popular bock being tapped as a seasonal. The year-round beer that gained the most popularity was Glorieta Lager. It was sold for a nickel at the saloons nearby such as the White Elephant, Free & Easy and the Bucket of Blood, which probably would not work as the name of a modern establishment.

At its peak in 1908, Southwestern was living up to its name, distributing throughout the New Mexico Territory, which still included present-day Arizona, as well as to neighboring states Colorado, Texas and Oklahoma. Southwestern was brewing an average of thirty thousand barrels of beer per year by 1910, most of it lager, a beer style that takes far longer to ferment than the ales that dominate the modern craft brewing scene. That total barrel output was nearly three times Albuquerque's population (11,020) and is still the most ever produced by a brewery anywhere in New Mexico. Santa Fe Brewing may finally surpass the thirty thousand mark after its recent expansion in 2016.

The brewery itself was a marvel of early twentieth-century engineering. Walter Elliot, who managed the successor company to Southwestern for some twenty-five years, told the *Albuquerque Tribune* in 1975 how the beer was made inside the five-story structure. "Pumps were not readily available in those days," Elliot told the newspaper. "Most were driven by steam and were inconvenient.…They'd start about four floors up with the first batch of hops in the brew kettle. Then they'd let it down into the settling tanks on lower levels where it was aged to some extent."

Southwestern still faced plenty of challenges from outside the state. The creation of refrigerated boxcars led to the arrival of numerous midwestern beer giants. Anheuser-Busch set up its distribution center along the train tracks right next to Southwestern. Miller, Pabst, Schlitz, Bohemian and more began to flood into the growing town. At the same time, the Rankins and the Loebs were locked in a lengthy battle for control of the brewery.

By 1916, Southwestern, deeply in debt, was taken over by new owners, Jacob Korber and Owen N. Marron, who changed the name to the Western Brewery and Ice Company. Korber was a local blacksmith and mercantilist who became president of the new company. Marron, who

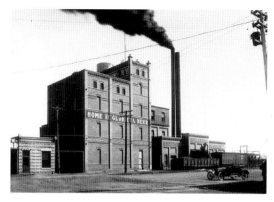

Left: The five-story brewery building was the tallest in Albuquerque upon its completion in 1899; the brewery expanded to thirty thousand barrels per year by 1910. *Courtesy of Albuquerque Museum.*

Below: The company logo for the Southwestern Brewery & Ice Company is still visible atop the building. *Courtesy of Mario Caldwell.*

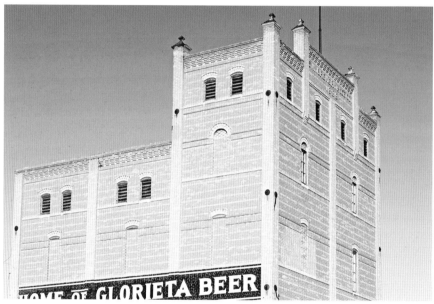

had served as the mayor of Albuquerque from 1899 to 1901, became vice-president. They had managed to right the ship and get the company back on its feet by 1917.

It would not last long, however, as Prohibition was soon coming to America. The Eighteenth Amendment, banning all alcohol production in the United States, was passed in December 1917. It was ratified in January 1919, and all beer production had ceased in every state across the country by January 1920.

The business was renamed the Western Ice and Bottling Company, sold to new owners in 1921 after Korber died in a truck crash, although Marron stayed on as president. Even after Prohibition ended in 1933, beer was

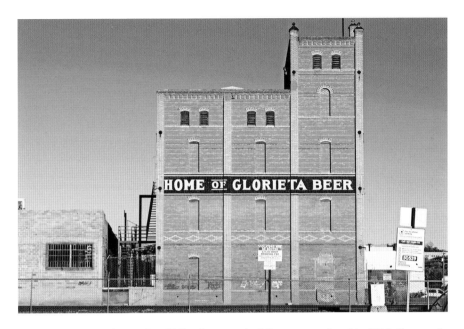

The Glorieta Beer sign on the old Southwestern building was repainted in 2016. *Courtesy of Mario Caldwell.*

never again made within its walls. It made distilled water and ice and would survive as an operational facility until 1997. A fire broke out on February 24, 1998, destroying the old warehouse located next to the brewing tower, which survived relatively unscathed.

The building, which never removed the Southwestern logo from one side, nor the "Home of Glorieta Beer" slogan from another, still stands to this day. It is a nationally registered historic place, although it has been empty for nearly twenty years.

Albuquerque was not completely void of any local brewing operations after Prohibition ended, although the two attempts to restart a brewery in town never came close to replicating the success of Southwestern.

The first mention of a possible post-Prohibition brewery in Albuquerque came in an *Albuquerque Journal* article from September 13, 1934. W.T. Head of the Equitable Securities Company announced the plans for an Albuquerque Brewing with his partners J.D. Lamb, the state corporation commissioner; Louis Paulos of Albuquerque; and Henry Howe of El Paso. The story noted that they planned to build a $250,000 brewery, although building plans were not yet complete. There was no further mention of this first attempt—it seems quite likely that raising that

much money in the midst of the Great Depression was difficult at best, impossible at worst.

Two years later, another *Journal* article mentioned the New Mexico Brewing Company. Brewmaster O.S. Schulz told the newspaper that the fledgling brewery was remodeling an ice plant in a four-story building located at the corner of North Second Street and Marquette Avenue in the midst of downtown. It would cost $45,000 to complete the remodeling, with the brewery signing a four-year lease beginning on April 1, 1936.

The plan was to be operational by the summer of 1937, with the project expected to employee twenty-five to thirty-five men in 1936 and upward of fifty once fully operational. Schulz projected that they would brew ninety barrels of beer per day. They would have ten brewing tanks with a capacity of 3,255 gallons apiece.

Schulz was listed as having previously built and operated breweries in Phoenix and El Paso. He was said to have been from Idaho Falls, Idaho.

Although the story said that brewing operations would not begin until 1937, an advertisement in the *Journal* posted in July 1936 noted that the brewery was up and running already: "The finest domestic material money can buy....Barley-malt and Hops are used. The Yeast, scientifically prepared from pure culture, comes from the world renown Institute—Wahl, Henius of Chicago....Water taken from our own well at a depth of 164 feet is used in making our beer. Samples of this water have been submitted to various laboratories, who have found it to be free from bacteria, and exceptionally pure and adaptable for beer making, without any treatment or bettering." The advertisement also noted, "72,000 gallons of beer will be held in the aging tanks at all times, so that a full aged product will be assured."

New Mexico Brewing announced that it was shutting down on January 3, 1937, to install a bottling plant and make other "minor changes." It also asked for local investors to contribute to the company's future, the first sign that financial problems were quickly mounting.

By January 23, these problems had forced a district court to order the sale of the 1,032 barrels of beer still in stock before they spoiled. Joseph Land, the appointed receiver of the failing brewery, then petitioned the court on January 30 to sell the brewery at auction. It listed liabilities at $36,000 and claimed its assets exceeded those liabilities. The court agreed, and New Mexico Brewing was auctioned off on February 17. After only two bids of $7,000 had been received, it was delayed until February 23, when $25,000 or more was sought.

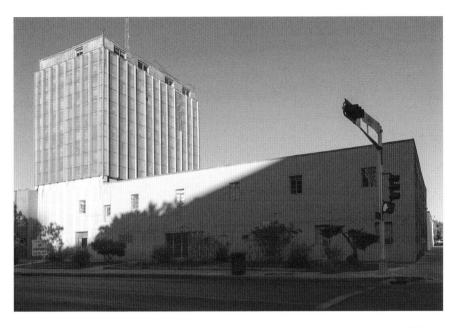

The building at 502 Second Street was the home of the short-lived New Mexico and Rio Grande Brewing Companies in the late 1930s. *Courtesy of Mario Caldwell.*

When no larger bid arrived even after the delayed auction, the court accepted the bid from San Francisco businessman Paul Von Gontard. He had incorporated the Rio Grande Brewing Company back in 1935, according to local business listings, but the project had remained in limbo. Von Gontard said that he would spend up to $125,000 to revamp the brewery and prepare it for distributing beer across the region.

Rio Grande began brewing in July 1937, selling to local bars and establishments. The Mint Café, located at 212 North Third Street, placed an ad in the *Journal* on October 5, congratulating the new brewery on its product. Rio Grande installed a $35,000 bottling line in November that could produce seven hundred cases per day. Among the beers brewed were Gold Trail, Rio Grande Lager Beer, Bavarian Winter Beer and Vaquero Beer.

A newspaper advertisement in May 1938 claimed that Rio Grande's sales were up "300 percent" as the state's only brewery. This boom in sales, whether true or not, apparently did not last. Rio Grande declared bankruptcy in 1939, stating that it owed $120,000, a staggering total for the time. It would mark the end of commercial brewing in Albuquerque, and New Mexico as a whole, for some forty-nine years.

The Wild West, 1988–1995

By the 1980s, the craft beer movement, then simply dubbed as microbreweries, was beginning to spread out across the West. The Boulder Beer Company had opened in Colorado in 1979, becoming the first brewery in the state just to the north of New Mexico.

Mike Levis, the owner of a sizable ranch in Galisteo, a rural community in Santa Fe County, took notice of the growth of breweries around America. Levis owned a company that supplied wine bottles to the many wineries popping up throughout New Mexico. He took a chance and purchased Boulder Beer's original, seven-barrel brewing system and had it installed in his barn.

The Santa Fe Brewing Company was born in July 1988, producing a pale ale in bottles that quickly gained a following across the state. Today, SFBC is the largest and most successful brewery in New Mexico, having long since left the farm for a growing complex along Interstate 25 south of the Cerrillos Road exit.

The first brewery to attempt to follow in Santa Fe's footsteps was in Albuquerque. Mike Buckner, a diesel mechanic and home brewer, decided to jump into the fray and create a new Albuquerque Brewing & Bottling Company that same year. The first bottles of Mike's Golden Ale rolled off a small line at the former Sunshine Fruit Drink plant at 637 South Broadway in August 1988, just seven weeks after Levis bottled Santa Fe Pale Ale. "It's not the kind of beer you drink all day while you work in the yard," Buckner told the *Albuquerque Journal* about his beer, which was more dark amber in color than golden.

Buckner leased 5,300 square feet in two buildings, assembling most of his equipment himself to save money. He was the lone employee, making the beer, bottling it and selling it. Buckner's beer retailed for seven dollars per six-pack at Quarters Liquors on Yale, near the University of New Mexico's football stadium. He could produce fifty cases per week.

In order to raise money, Buckner said that he was planning to do an initial public offering under the New Mexico Securities Act K exemption, enabling others to buy stock in his fledgling company. The minimum requirement was for two thousand shares at fifty cents apiece. Buckner planned for a ten-barrel brewhouse and future expansion to twenty-five thousand barrels per year worth of production.

The plan did not generate the return that Buckner had hoped for, forcing him to enter into a merger agreement with Parkway Capital Corporation, a publicly traded Colorado company, in December 1989. "This merger does several things for me," Buckner told the *Journal*. "It gets me the infusion of capital I need to operate and continue the business plan, and still leaves me in control of the company."

From that point onward, whatever happened to Buckner and his fledgling brewery was a mystery. Albuquerque Brewing quietly disappeared from the scene, having never made any additional styles of beer and never opening a planned taproom, and as Buckner had no remaining connections to the current metro-area beer scene, his name was lost to the annals of history as well.

Assets Grille and Brewery

After three years of inactivity, Albuquerque's nascent beer scene began to come to life in 1993. It would mark the dawn of a new era of breweries. In general, three distinct types of breweries emerged. On one hand, an existing restaurant would install brewing equipment and begin making its own beer, transitioning to the status of a brewpub. Another option was to open a brand-new brewpub, making fresh beer alongside the food right from the start. The third design was to create something similar to what Buckner had, a production facility that only packaged its beer and sold it to bars, restaurants and liquor stores.

The dawn of the new brewing era came when Assets Grille, a popular restaurant in Albuquerque's Northeast Heights located on Montgomery just west of Louisiana, installed its own brewing system in early 1993. The

ownership trio of Don Goodenough, Doug Smith and Russ Zeigler wanted to reinvigorate the old restaurant, which they had purchased back in 1977, sold a decade later and reacquired in 1991. By May 1993, brewmaster Mark Matheson's creations were rolling into the adjacent restaurant and into the glasses of thirsty customers. Matheson had learned how to make beer and wine at the University of California–Davis. He was working full time at a local winery in Sacramento when he learned about Assets' plans in 1992.

"I had gone to Davis and home brewed forever," Matheson said. "My wife knew one of the owners of High Finance/Assets. They said they were going to do it, but I didn't have any commercial experience. What I'd do, I'd needed to be at work in the foothills [winery] at 9, so this is the old Rubicon Brewing Company. This is the first turn-key brewery, a ten-barrel system. I'd go in at four in the morning, help them brew, really just learn the ins and outs of the equipment."

Matheson ended up working part time at Rubicon for a year, mainly due to the fact that Assets was having a hard time convincing the State of New Mexico to allow it to add a brewing system. "Assets, because they had a full liquor license, they had a really hard time because New Mexico's [not] the most forward-thinking in license and regulation," Matheson said. "It took

Assets Grille, a popular restaurant in the Northeast Heights, installed a brewing system in 1993. *Courtesy of Mark Matheson.*

them about a year, a year and a half, to get the brewers license with the full liquor. We opened in April of '93."

Matheson had at his disposal a seven-barrel pub brewing system that was, for the time, a state-of-the-art system for Albuquerque. He had two fourteen-barrel fermenters, two seven-barrel fermenters and small vessels called grundies in which to age his beer. "This was a really good system, I think," Matheson said. "It was a very well-built system; it had a manifold on the front. For a pub, I think it's still up to date."

Among the beers produced at Assets were Kaktus Kolsch, Roadrunner Ale (English bitter), Albuquerque Pale Ale, S.S. Rio Grande Copper Ale, Sandia Stout, Pablo's Porter and the brewery's best seller: Duke City Amber. Seasonals ranged from the Fruit that Ales You, where the fruit used would change by the season, to the Ol' Avalanche Barley Wine in the winter, Red Eye Rye for St. Patrick's Day and more. While other breweries of the era would speak to the difficulty in attracting customers, Assets already had a strong base.

"It really wasn't hard," Matheson said of getting people to try his beer. "We had a full lineup. We had a regular American wheat, and then we did a flavored fruit beer; it was our American wheat with fruit flavoring. We would rotate out flavors."

The Fruit that Ales You was popular with all sorts of people. "I had this guy come to me in the brewery while I was brewing—he was about six-[foot-]eight and 350 pounds and he wasn't fat, he was just this big rancher," Matheson said. "He pushes this finger in my chest and says, 'You, mister, have got to think about getting cherry wheat back on tap.' I'm like, 'It's in the pipeline sir, we're going to get it done.'"

Assets was making the type of beer that, in that period, was popular with customers. "The level of craft beer, it wasn't nearly as hoppy, it wasn't nearly as alcoholic [as today]," Matheson noted. "It was a different feel. We were an ale house. I don't think that American brewers, except guys like Gordon Biersch who had a really Germanic tradition, or Sierra Nevada, those guys are real lager heads—none of us pub brewers knew how to do lagers. We'd do Oktoberfests, but it was still a single-infusion mash and we had the yeast, but we still didn't understand the interplay of water. It wasn't as hard as you would think. The market wasn't as big, and we were trying to sell something that was quaffable, sessionable, easy to drink."

Albuquerque was suddenly developing a thirst for locally made craft beer. It would not stop with Assets.

RIO BRAVO RESTAURANT BREWERY

The success of Assets' brewing operation in the Heights did not go unnoticed by people in other parts of the city. The husband-and-wife team of Frank and Lisa Smith joined forces with her brother, David Richards, to launch the Rio Bravo Restaurant Brewery in the heart of downtown Albuquerque in the summer of 1993.

Rio Bravo took up the space that had been long occupied by the Simon's Western Wear store at 515 Central Avenue. Iconic for its neon-lit, rope-swinging cowboy sign outside, much of the site's original décor and atmosphere were retained for the new brewpub.

Frank Smith had a law degree from Santa Clara University in California, where Lisa earned her master's in business administration. Richards had spent ten years in the restaurant business, including time working for the Intercontinental Hotels chain in Abu Dhabi. Frank Smith was named president, with his wife serving as chief financial officer and Richards as general manager.

None of the trio, however, had any experience making beer. Brad Kraus, who had been hired by the Levis family to serve as brewmaster at Santa Fe Brewing, was hired away by Rio Bravo.

The Rio Bravo Restaurant and Brewery occupied this space at 515 Central Northwest in the mid-1990s. *Courtesy of Mario Caldwell.*

"It was an interesting time," Kraus said. "I was living in Santa Fe and commuting down there five days a week. That got old. But we made some really great beer. We had Michael Jackson come during that time. He was a dear friend; I miss him dearly. It was an interesting [time] because it was more a gastropub than a traditional brewpub. We were trying to do a little higher-end food. That's why I say I think we're ahead of our time, and it may not have worked. It's hard to maintain that level."

Initially, Kraus had a light ale, medium lager, a stout and a rotating seasonal to pair with dishes ranging from mesquite-grilled meats, pastas and some New Mexican fare, with plates generally ranging between twelve and twenty dollars. The ten-thousand-square-foot restaurant could seat up to three hundred people. Over time, the most popular beers from Rio Bravo became the Coronado Gold, High Desert Pale Ale and Esteban Dark, a porter. The brewery had even started a "Downtown Sunday Brunch" by early 1994. It was cited as a major part of the ongoing renovation of downtown, which was quickly becoming a destination for many people. Mayor Martin Chavez frequently used Rio Bravo as a site for fundraising.

The success of Rio Bravo caught the eye of at least one established Albuquerque restaurant to the east.

IL VICINO BREWING

In addition to the Heights and downtown, another popular area for eateries in Albuquerque was the Nob Hill neighborhood along Central Avenue, old Route 66, just east of the University of New Mexico. Typically defined as being east of Girard and west of Washington, this multi-block stretch featured a wide array of restaurants, bars, shops and even a few motels.

Nestled near the heart of Nob Hill was a small restaurant known for its wood-fired pizzas called Il Vicino. Tom Hennessy ran the successful establishment and soon became aware of the newfound success that Assets and Rio Bravo were enjoying thanks to their in-house brewing operations. With limited home brew experience, Hennessy hired Rob Chavez, who had assisted Matheson at Assets, to brew in a tiny ten-foot-square room in the back of the restaurant.

That was the first brewing experience for Chavez in a commercial setting. He had previously worked on the aerial tramway in the Sandia Mountains and had a mechanical engineering background. Chavez set up the brewing system and got to work in 1994. One of the employees

Il Vicino brewed in its tiny Nob Hill restaurant space back in 1994. *Author's collection.*

working out in the restaurant was Brady McKeown, who had become friends with Chavez. "He was the brewer for six months or something like that," McKeown said. "Then it got busy enough that he needed some help. He worked there and I worked there. He was goofy and he was fun. We'd go mountain biking and stuff and hang out. I started helping him. That was the beginning of my brewing."

McKeown had brewed at home twice but found it boring since it was always going off someone else's recipe. He found brewing with Chavez, even in some seriously cramped quarters, to be much more enjoyable. The customers, though, did not feel the same about the beer. "The first stuff that we made at Il Vicino was horrible," McKeown said. "At the time, before we opened the brewery, Celis had just come into New Mexico [from Texas]. I think Il Vicino had the first Celis taps. We had Celis White, Celis Ale—trying to get people to drink our crap over Celis, it wasn't happening. When we started, we had no temperature control on the fermenters. Slowly, things got better and better. It was warm fermentation like home brew. It was just a very large batch of home brew."

McKeown, Chavez and the rest of the staff had to make do with what they had, although they often had to jury-rig the equipment. "We got the grundies and the serving tanks," McKeown said. "We put a hole in the wall of the cooler because we shared a wall with it. We put a dry air hose, and we got house insulation, taped it to it and covered it. It was horrible. It caused you to like Celis that much better."

Tragedy struck in early 1995 when Chavez died in a motorcycle crash. McKeown was promoted to head brewer. At the time, only their Old Route 66 Golden Ale had much of a following. That would change in part because of Hennessy, who was opening additional Il Vicino restaurants in Colorado, and in part thanks to technological improvements.

"Eventually we got temperature control," McKeown said. "At the same time, Tom had been brewing in Salida, and he came up with the Wet Mountain [India pale ale] recipe. That followed [because] we had better extracting up in Salida. It was like a 9 percent IPA. Our first batch freaked everybody out. No one was really drinking anything that hoppy in New Mexico at the time. It was really nice."

The dawn of the IPA style in New Mexico would change the game. Finally, a beer had come along that could hold up to the spicy green chile that people were putting on just about every conceivable food item.

RIO GRANDE BREWING

The final piece of the puzzle came later in 1994, as Albuquerque's first production-only brewery arrived in the form of a second Rio Grande Brewing Company in July. With no connection to the 1930s brewery, this new operation was started by friends Scott Moore, Tom Hart and Matt Shappell.

Located at 3760 Hawkins Northeast, the new Rio Grande was solely focused on either bottling or filling kegs for other businesses. At no point did Moore, the company president; Hart, the head brewer; or Shappell, the director of operations, ever consider opening any sort of taproom or even a simple tasting area for their beers. If anyone wanted to try Outlaw Lager, their flagship beer, people would have to go to their nearest liquor store or any bar or restaurant that carried it on tap.

Hart, a Presbyterian minister, was a member of the local home brew club the Dukes of Ale. Moore, who came from a wealthy family, sponsored Hart in numerous competitions. After a three-year run of success, the duo teamed up with Shappell to enter the brewing scene, albeit with a different concept than what Assets, Rio Bravo and Il Vicino had done.

"They used to call themselves the 'Yeastie Boys,'" said Sierra Blanca Brewing owner/brewer Rich Weber with a hearty laugh. "I met those guys early on, just because when I was getting into [business in 1996] I wanted to go talk to guys that were into it."

This nondescript industrial building at 3760 Hawkins Northeast was home to the second iteration of the Rio Grande Brewing Company from 1994 to 2007. *Author's collection.*

Rio Grande took over a warehouse that was formally leased to the Gruet Winery. It already had the trench drains in the floor that they needed. Rio Grande was soon bottling one thousand cases per month, accounting for three quarters of their total production. The rest went into kegs, which by late 1994 were being tapped at around fifty bars and restaurants. "It was almost too good to be true," Hart told the *Journal* in an October 17, 1994 article. "We thought maybe we should take advantage of this niche."

The Outlaw Lager logo, a longhorn cow skull with mountains in the background, became a popular image for New Mexico beer drinkers in the 1990s. Other beers would eventually follow, with the Pancho Verde Chile Cerveza, introduced in 1997, soon rivaling the Outlaw as Rio Grande's top seller. The Desert Pils and Elfego Bock were also widely available.

Rio Grande had found its niche and would survive for more than a dozen years, overcoming the brewery collapse that would occur later in the 1990s. It laid the groundwork for many of Albuquerque's future distribution breweries.

The Second Wave, from Boom to Bust, 1996–2000

The second half of the 1990s saw the number of breweries and brewpubs in Albuquerque more than double. It also saw a series of crashes as some of the brewpubs failed to gain a foothold.

Even for three of the four carryovers from the first half of the decade, changes would be afoot. Il Vicino moved head brewer Brady McKeown to Colorado Springs to start a brewery there in 1996. His replacement, Jason Ackerman, would later oversee the move to a larger, brewing-only facility on Vassar north of Comanche.

Rio Bravo, in the meantime, would see the departure of Kraus in 1996, as he headed back to Santa Fe to start Wolf Canyon Brewing. His assistant, Daniel Jaramillo, would take over as head brewer. "Daniel was working in the kitchen, and when my assistant left, moved to Austria, he was like, 'Man, I want to help you in the brewery,'" Kraus said. "'You're not going to get paid as much,' I told him. 'No, I really want to do this. I'm tired of working in kitchens. I've done it for thirteen years, I'm burned out.'"

Jaramillo, who is now the director of brewing operations at La Cumbre, said that the transition was not nearly as easy as he thought it would be. "I was way green behind the ears," Jaramillo said. "I remember my first mash….All I remember was I kept mashing at 156 when I was supposed to be at 165. Brad wasn't too happy about that."

Over time, though, Jaramillo began to shine. "He definitely is, in one of my thirty-some-odd years of brewing, he was one of the three best assistant brewers I've ever had in my life," Kraus said. "We'd almost finish each

Il Vicino moved its brewing operations from the Nob Hill restaurant to this industrial complex at 4000 Vassar Northeast in the late 1990s. *Author's collection.*

other's sentences. We did everything the same way. It was fantastic to have him working there."

Assets Grille and Brewing announced expansion plans in February 1996. The neighboring restaurant, Charlie's Other Door, did not renew its lease, enabling Assets to take over, knock out the existing wall and double its available brewing space with another three thousand square feet. Assets' owners said that they would install a bottling line and even a retail outlet where they could sell six-packs. Rather than call it Assets Brewing, the decision was made to reach into the past and call it Southwest Brewing Company. The first two beers scheduled for bottling were Duke City Amber and Roadrunner Ale.

As Rio Bravo, Il Vicino, Rio Grande and Assets kept evolving, they were about to be joined on the scene by several new breweries.

CABEZON BREWING

Albuquerque's second production brewery came into existence in 1996. Mike Carver started Cabezon Brewing, following Rio Grande's model of brewing in one place and selling beers through package or kegs to bars and restaurants.

In contrast to the hop-fueled beer market of the present, Cabezon's best seller was this wheat ale in the 1990s. *Courtesy of Mike Carver.*

Carver had spent most of his adult life working for Johnson & Johnson in research and development, mainly out of its facility in Denver. "My driving force to opening a brewery was I wanted to get out of 'Corporate America,'" Carver said. An avid home brewer, Carver opted to tackle that as his new

career. He purchased the property for a small warehouse in Albuquerque, one block north of Montano, just off Edith. The ground was broken on Cabezon Brewing on April 1, 1996, and Carver was brewing by July 4. "That's all we did was bottle and keg three beers," Carver said. "Our taproom was a tasting room, basically. We sold growlers out of the taproom, just those and samples."

Those three beers were Sunchaser Ale, Anasazi Wheat and Cabezon Stout. Getting them out to the public, however, proved to be a bigger challenge than he had expected. "It was a different world back then. You had to convince people to try your beer back then. It's not like it is now. You had to really convince bars and restaurants to carry handles for you," Carver said. "I was distributing through New Mexico Beverage. They were doing a good job. But, those games, in the distributor world [then] is about the games....Back then the way you got a tap handle was a restaurant or bar would call you and ask to carry your beer, but there was always something attached. There was a new cooler door. At the airport, it cost me $10,000 in fees to this guy's favorite boxing program. It was very crooked, but that's the way it was."

The brewery could produce up to one thousand barrels per year on a twenty-one-barrel brewhouse, a system cobbled together from used dairy equipment, plus equipment purchased from Left Hand Brewing in Colorado. Carver used his own engineering and chemist skills to improve and enhance what he had available.

Cabezon's beers were reaching the shelves and tap handles around town alongside Rio Grande and Santa Fe. Other breweries opening during the period, however, stuck with the brewpub model.

KELLYS BREW PUB

Anyone involved in the business of alcohol distribution knew of Dennis Bonfantaine long before he and partners decided to open a brewpub in Nob Hill. Bonfantaine's chain of Kelly Discount Liquor Stores was popping up all over Albuquerque. He was also involved in the same New Mexico Beverage Company that distributed Cabezon and other local breweries' beers.

In 1996, Bonfantaine teamed up with Paul Perna to take a concept the latter had seen in Canada and bring it to Albuquerque. Kellys BYOB opened

The BYOB (Brew Your Own Beer) system at Kellys was a popular feature for customers from 1997 until it was eventually discontinued in 2015. *Author's collection.*

in December along Central Avenue, a block and a half west of Il Vicino on the south side of the street. The initial concept invited aspiring home brewers to come in and make their own beer. The cost was $100 to $135.

Due to licensing issues, Bonfantaine eventually opted to start brewing his own beer as well, hiring David Blackwell to run the brewing operation. Blackwell, in turn, hired a local home brewer he knew named Doug Cochran to serve as his assistant.

"It was late '96, like a couple weeks before Christmas," Cochran recalled. "I was around doing odds jobs, not really using my degree in English lit, just a home brewer….I didn't think about that [as a career] until this guy calls me up, he's another friend of mine and tells me that a place has opened up and they need cooks and dishwashers. I was like, 'What do you mean?' and he said, 'It's a brewery.' He goes, 'They're hiring, man, you should go over there and check it out. I got hired in the brewery.'"

Cochran was surprised since his friend had never home-brewed before. Noting this, he decided that it was time to throw his hat into the ring. "So I called them up and one of the managers says [to] come on down," Cochran said. "I go down and fill out an application. The guy Dave wasn't there, so it was the other manager, and he asked what position did I apply for. I told him I'd been a home brewer since 1989 or 1990. I get a call from him a couple days later to come in for an interview for me. Dave saw me and said he knew me, he knew I made great beer. I got hired. That was really cool."

Cochran said that he did not want to get into teaching and had pretty well given up on becoming a writer. As he and his wife were looking to plant roots in Albuquerque, his onetime hobby had suddenly become a career. "It was really just a big extract brewery; it wasn't any different than what I was doing at home," Cochran said. "Obviously on a bigger scale. This guy Dave was a little older than me, a couple years older than me, so we hit it off. I said, 'Hey man, I need forty [hours],' so he made sure I was his right-hand man. He showed me how to do everything in the brewery—dealing with customers, doing the cellar work, cleaning kegs, everything."

Kellys was a big hit with its combination of letting people brew their own beer, plus the house beers and food. "At the time, Kellys was the new thing in town, nobody had done that before," Cochran said. "We took that rinky-dink little BOP system and actually made it shine. We instituted a liquid yeast program in it. When we first started, we had dry yeast; that will ferment anything, but if you actually want a range of flavors, you don't want the same Nottingham flavor in everything you do. We did that, and once we started using liquid yeast, it was night and day."

Kellys' status as the new kid in town ended fairly quickly. Two new breweries would arrive in 1997, albeit in two different locations.

SAN YSIDRO BREWHOUSE

The success of Rio Bravo prompted businessman Geoffrey Cooper to launch his own brewpub in the heart of downtown. San Ysidro opened in September 1997 at 405 Central Northwest, right on the northwest corner of Central and Fourth Street.

San Ysidro featured a mix of brewing equipment that was cobbled together from the former Elephant Butte Brewpub in southern New Mexico, plus some additional used dairy equipment. Guy Ruth, a longtime member of the Dukes of Ale home brew club, was named head brewer despite not having any commercial experience. His first beer was an India pale ale, inspired by the success of Wet Mountain IPA at Il Vicino.

The food menu was more upscale, reminiscent of what Rio Bravo had to offer. Pasta, pizza and sandwiches dominated the lunch menu, with prices in the seven- to eight-dollar range. The extensive dinner menu had steak, seafood and numerous other expensive items. Prices ranged from eleven to eighteen dollars.

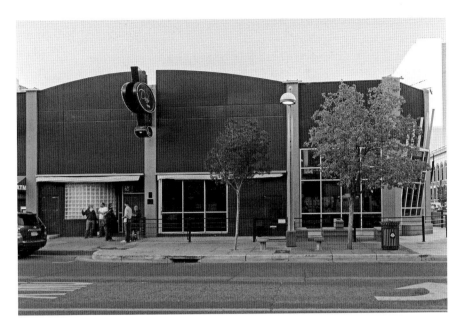

The former home of the San Ysidro Brewhouse downtown has been occupied by many different bars and restaurants in the years since it closed in 1998. *Courtesy of Mario Caldwell.*

Despite the food and the location, San Ysidro had a hard time with the beer. "There was San Ysidro downtown. I went and tried one of their beers," Cochran said. "It was infected, it was bad. They had some old dairy equipment. I wasn't sure if they were sanitizing."

Nico Ortiz, who would go on to found Turtle Mountain Brewing in the suburb of Rio Rancho in 1999, also remembered visiting San Ysidro after it opened. Ortiz had become friends with Brad Kraus at Rio Bravo, and the two of them headed down the street one day. "It was a novel concept. There were two brewpubs down on Central. There have been zero [since]," Ortiz said. "I think that was the first time I've ever seen [Brad] take a sip of the beer and push it back across the bar because it was so awful. They had dairy tanks in the window. He had to Saran Wrap them. That's not an effective means of keeping bacteria and infection out. I love Guy to death, but San Ysidro, that place was just dreadful."

San Ysidro's struggles could have been a warning to other prospective brewery owners around town. Ultimately, its problems were seen as an isolated incident. Time would prove otherwise.

BAVARIAN LAGER CELLAR

Andy Dunagan graduated from the New Mexico Military Institute in Roswell in 1987. A decade later, he announced his plans to return to Albuquerque and open his own brewpub. Inspired by his time in Germany, Dunagan made plans for a brewery that would focus only on German-style beers. Located at 7120 Wyoming Northeast in the Del Norte Shopping Center, Dunagan's creation would expand a five-thousand-square-foot building into eight thousand.

"I don't think there are too many brewpubs in Albuquerque," Dunagan told the *Albuquerque Journal*. "We're all pretty dispersed, and everybody in Albuquerque is brewing ales based on the English tradition. I'll be doing lagers based on the German tradition. It's like apples and oranges."

In addition to a full menu of German food, Dunagan planned to brew a golden lager, a marzen, a doppelbock, a summer festival lager, a low-calorie/low-alcohol lager and a hefeweizen. To implement the brewing of those beers, Dunagan hired Jaramillo, who had left Rio Bravo after an ownership dispute had temporarily closed the downtown brewpub.

"Brad called me up. He sold Andy Dunagan the brewing system," Jaramillo explained. "He asked Brad if he knew of any brewers who would be interested in working with him. Brad put my name in the hat. Andy hired

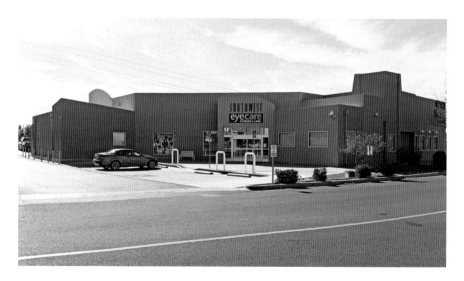

Once home to the Bavarian Lager Cellar and Dry Gulch Brewery, this Northeast Heights building is now an optometrist's office. *Author's collection.*

me. I liked the idea of brewing lager beers and really clean beers. Granted, not many of our beers were very clean. There towards the end we won a goal medal at World Beer Cup for a bock. We were actually starting to come into our own with the beers."

The brewery was impressive in its size and scope. It might have just been a little too specialized, and quite a bit over budget, for the time. "Bavarian Lager Cellar, if you had seen that place, my god," said Sierra Blanca Brewing owner/brewer Rich Weber. "The equipment, just to go in there and see the German decoction [system], it was gorgeous. It was ahead of its time, the lager theme."

Money problems, though, were beginning to mount for Bavarian Lager Cellar. By late 1998, the situation there was growing dire. It was far from alone.

From Upheaval to Implosion

The cracks in the local scene had started at Rio Bravo in early 1997. The ownership team had splintered. Richards had left to start a new restaurant. Frank and Lisa Smith were having a hard time keeping things in order.

Jaramillo said that he was told the brewpub was shutting down temporarily to get its affairs in order. He and other employees saw their last paychecks bounce. Richards would return to reopen Rio Bravo later in the year, although by then he had to hire an entirely new staff. Mike Campbell, a former home brewer who had limited experience helping out Hart and Moore at Rio Grande, was hired as the new head brewer. "At that time, there was nobody else in the city who could have stepped in and had any knowledge of moving commercial beer from one tank to another," Campbell said. "I was the last brewer. I knew Daniel at the time. The place opened and closed [pretty quickly]."

One final change came late in 1997 when Rio Bravo had to change its name to Alvarado Restaurant and Brewery. Applebee's, the national chain restaurant, had opened the Rio Bravo Cantina in the Southeast and had sued to change the name a year earlier. In the end, Frank Smith received a sum of cash from Applebee's to change the name, which Smith took from the Alvarado Hotel, where his grandfather had worked before it was demolished in 1970.

Even with Richards's return to help his sister and brother-in-law, and Campbell's hiring, Alvarado failed to survive. It shut down in 1998, but it

was hardly the only place to go belly up. Before the year was out, San Ysidro had also called it quits, unable to ever generate the same buzz as its neighbor had years earlier.

Dunagan, in the meantime, was unable to keep Bavarian Lager Cellar afloat. It also shut down in 1998, leaving Jaramillo without a job again.

Those breweries, plus Volcano Brewery in Rio Rancho, all died off in 1998. Even for the breweries that survived, there were still problems to overcome. "It was funny because as it was closing down, I put in my résumé to Santa Fe Brewing, Sierra Blanca, but it was hard—nobody was hiring," Jaramillo said. "Places were shutting down. Everybody was making diacytel-laden beers. The only place that was making good beer was Assets."

Over at Assets, though, Matheson's relationship with ownership had soured amid the new expansion and decision to start bottling. "I was invited to leave on my thirty-fifth birthday," Matheson said. "Things happen. The beer business is a very, very tough business. It's very capital-intensive. It's very demanding financially, physically and mentally."

Matheson went to work for Santa Fe Vineyards, getting back to his first love, winemaking. He would return to beer a year later with Ortiz at Turtle Mountain. Jaramillo, in the meantime, was hired to fill Matheson's spot with Assets.

Meanwhile, over at Kellys, change was also afoot. The owners of the building were not interested in renewing the lease. Bonfantaine had his eye on the Jones building, a historic site that used to house a Ford dealership and a Texaco station located just a few hundred feet to the east at the corner of Central and Wellesley. Change was also coming to the brewing staff. "I was there from '96, and then Dave got a job [at Belmont Brewing] in Long Beach and left in '99," Cochran said. "I ran the brewery for that last year I was there, and knowing that they were going to move, and knowing that the owners didn't want me to be there any longer than I had to be, I wasn't the yes-man they wanted."

Kellys would move to its current location and reopen in April 2000. It proved to be a major hit, particularly with the spacious outdoor patio. Still, it was the beer that brought in the first customers, Cochran said. "We put that place on the map—myself, Dave, the other brewers over there," Cochran said. "In my opinion, what they did afterwards, it was good for them, they got the [new] building and everything, it really helped out Nob Hill. I was just lucky to get in. Ever since then, people have been opening breweries left and right."

Cochran would not be out of work long. He joined the brewing staff at Il Vicino soon afterward and still works there to this day. "I didn't know

Kellys Brew Pub actually began its existence in the small Korean barbecue restaurant space to the right before moving up the street to its current location in 2000. *Courtesy of Mario Caldwell.*

Brady at the time, but they got rid of the old brewer, Jason Ackerman, and had Brady come back down from Colorado Springs," Cochran said. "I pretty much went over, met Brady at the old brewery, gave him my résumé. I told him I worked at Kellys, and he said, 'As far as I'm concerned you're good. I just have to talk to the owners.' Had an interview, pretty much in. That was 2000."

BLUE CORN BREWERY ALBUQUERQUE

As the dust settled from the great shakeout of 1998–99, however, it was a Santa Fe–based brewery that would bring some light back to Albuquerque. It was certainly not an overnight success, but the arrival of Blue Corn Brewery would ultimately lead to the eventual brewery boom of the twenty-first century.

Blue Corn had started as a small café, specializing in New Mexican food, just off the Plaza in downtown Santa Fe. Owned by the powerful

Santa Fe Dining Company, Blue Corn joined the list of existing eateries to add an in-house brewery during the 1990s. In order to do so, it had to open a larger restaurant on Cerrillos Road, far from downtown but close to a large number of stores, restaurants, hotels and businesses on Santa Fe's southwest side.

"In 1996, they hired Jeff Jinnett, and he came in as the guy that was going to do the expansion of Blue Corn and open this next restaurant with a brewery on the south side of town," said John Gozigian, who had worked up to that point as a general manager within Santa Fe Dining's many restaurants. "Within a year, that happened. He came on board and worked with us at the downtown location for a while. Then he went out and started the process of opening the brewery."

With Jinnett running the show and Laure Pomianowski, the state's first female head brewer, in charge in the back, Blue Corn opened and began brewing beer in January 1997. "It was Blue Corn Café and Brewery," Gozigian said. "Previously, we had specialized in tequila and tortillas, New Mexican food. We added the brewery component. This was during that time when a lot of restaurants around the country were adding brewery modules

The first "imported" brewery in town, Blue Corn, was up and running by 1999 off the Interstate 25 frontage road. *Courtesy of John Gozigian.*

to their existing operations. It was part of that '90s wave of breweries that kind of went bust."

Blue Corn, however, survived the late '90s purge. In part, that was due to Blue Corn not aiming too high. Gozigian noted that while many brewhouses were twenty barrels and up, pushing far beyond the limits of the home brewers they frequently hired, Blue Corn stuck with a seven-barrel system.

"We opened that restaurant, and the restaurant was fairly successful," Gozigian said. "We sold a fair amount of beer almost by accident. I say by accident because people weren't going there for the beer. They were going there because it was Blue Corn, and we had decent New Mexican food and we had a full bar, so it was a place to hang out and watch sports and stuff. The beer we had on tap was our own beer. We had to have Coors Light and Corona in bottles because you couldn't not back then."

Getting the public to even understand that Blue Corn was a brewery was harder than anyone expected. "A lot of people drank our house beers because just because," Gozigian said. "It was an incidental sale, not so much because of any specific reason with the beer. In fact, I remember we did a survey, I think it was the second week we were open, and one of the questions was, 'Did you know we're a brewery?' And a surprising number of people, like more than half, said no. We had those big bright tanks in front. I don't know what people thought they were. The brewery was all the way in the back of the restaurant, so if you didn't go back there you didn't see it."

The Blue Corn model still proved to be successful enough that Santa Fe Dining began to eye Albuquerque for future expansion. Rather than push the existing brewery beyond its limits, the decision was made to open a new restaurant with a separate brewhouse. "It was actually January of '97 that we opened Blue Corn in Santa Fe. Then it was in August of '99 that we opened Blue Corn Brewery in Albuquerque," Gozigian said. "It was a Blue Corn Brewery originally. Our assistant brewer from Santa Fe came down as head brewer, and we hired Ted [Rice] as assistant brewer."

It was the hiring of Rice that would prove to be the ultimate success story for the new Blue Corn location. He would soon move up to head brewer. Rice, along with Gozigian and Jinnett, later came up with the idea that launched the great craft beer boom in Albuquerque and the rest of New Mexico.

Craft beer entered the twenty-first century in New Mexico teetering between explosion and extinction. Its ultimate fate would be decided by a tiny offsite taproom in downtown Albuquerque.

New Century, Same Problems, 2000–2008

The issues facing Albuquerque's breweries did not simply go away with the start of the new decade. The future was still uncertain for all of the survivors from the '90s—Assets, Blue Corn, Cabezon, Il Vicino, Kellys and Rio Grande—for various reasons.

Out of the group, Il Vicino may have found the most stability. Brady McKeown had returned from Colorado Springs and retaken the reins at the Vassar facility, with Doug Cochran now part of his team. "We had Rio Bravo equipment—well, used Rio Bravo equipment," McKeown said. "They took all the grundies, the serving tanks and then in storage they had all the original equipment. We sold the kettle to the guys next door. The guy wanted a hot liquor, well, hot water tank for his house."

Used equipment or not, McKeown and Cochran made for a good team. "He taught me a lot. He taught me all-grain, a lot of the little things in brewing. How they're real similar but a couple procedures are different," Cochran said of McKeown. "Coming in with him, with all the medals and stuff, stepping up to the plate with a company that actually is tried and true, it's nice. Kellys had pretty much forged that place around us. It was nice to go to a place with a customer base, had some medals already. It challenged me to step up, not just take things for granted and be lackadaisical. Brady was a good guy, always pushing us, trying to make us learn more. It was really a big step up."

While Il Vicino quietly flourished, the other breweries were struggling. It did not stop one more brewery from opening in 2000, taking the place of one that had closed two years earlier.

DRY GULCH BREWING

The former home of Bavarian Lager Cellar was transformed into Bubbe's Kitchen, a Jewish-style deli, back in 1998. That concept struggled and sputtered, and the decision was made to turn it into a brewery again. Dry Gulch Brewing and Grill opened in 2000, with Guy Ruth getting a second shot at being a head brewer after San Ysidro had closed two years earlier.

Dry Gulch offered up beers such as Where the Helles, Double Mountain Kolsch, Double Mountain Pale Ale, the IRA (India Red Ale) and Hop Lava. Much like its predecessor, however, Dry Gulch failed to catch on with the public. Even with a different owner, it had the same problem as Bavarian, with too big of a system and not enough capital to back it up. "I felt bad for Guy Ruth. He got stuck on that system and was totally overwhelmed," said Turtle Mountain owner Nico Ortiz.

By 2002, Dry Gulch had closed. Two years later, the building was transformed from a restaurant/brewery into an optometry center.

CHAMA RIVER BREWING

Meanwhile, change was afoot over at Blue Corn Albuquerque. The location on the Pan American Freeway frontage road was struggling to find its footing. Its first saving grace came when Ted Rice was promoted from assistant to head brewer. Rice was originally from the East Coast. "It was in June of '99 when I moved from my first head brewer's job in Miami Beach, Florida, to Albuquerque," he said. "In Miami Beach, I was running a two-barrel brewhouse. It was a multifaceted operation where it was a hotel, restaurant, pool, stage, bars…the brewery was just a small part. That business changed hands, [and] the new owners decided to take out the brewery."

Rice and his wife then made a fateful decision, although it was driven more for her benefit than his. "Amberley and I decided we would follow her career path, and she wanted to work on her PhD in English in the Southwest," he said. "She wanted to go to UNM. I found a job posting for an assistant brewer posted by Cullen Dwyer, who was the head brewer at Blue Corn on Cerrillos at the time. I met Jeff Jinnett at the Craft Brewers Conference in Phoenix in the spring. He interviewed me for the assistant brewer's job, traveling between Blue Corn in Albuquerque and Blue Corn in Santa Fe. I showed up in town. Blue Corn Pan American was still under construction."

Head brewer Ted Rice (*right front*) entertains customers during a beer dinner at Chama River. *Courtesy of John Gozigian.*

Tim Wilson was moved to Albuquerque to run the new brewery, but after he struggled in the role, Jinnett replaced him with Rice. It was not an overnight turnaround. "They underestimated the potential of a brewery or overestimated the success of a New Mexico–style restaurant in that sea of chain restaurants," Rice said. "The restaurant was not doing that well, so they transformed it later on."

Before the name and menu would change, Rice got the chance to improve the brewing process. "After I took over, things clicked in my mind when it comes to process, procedures and just making beers," Rice said. "Being there on site and engaging customers, day in and day out, the brewery took hold. The brewery on Cerrillos had never really entered GABF. I think maybe they did by 2000 or 2001. We had our first major competition opportunity in 2002 [at the World Beer Cup]."

Rice brought home two medals from the WBC for the two beers he entered, Red Dragon Lager and Get Off My Bock. The former won bronze in the American-Style Amber Lager category, and the latter won silver in the Traditional Germany-Style Bock category. "That was fun," Rice said.

"Things were a little bit easier. There weren't as many breweries competing as there are now. Things started to gel for me as a brewer. I understood the flavors I wanted."

Rice's success beyond the medals did not go unnoticed. "The Blue Corn Brewery in Albuquerque, it just wasn't doing too well," said John Gozigian, who was then the general manager. "Sales were going like this [downward] from the start. Kind of around 2002 or 2003, I noticed the beer sales were actually going the opposite direction. I noticed people at the bar actually ordering [just] beer, talking about the beer, more interested in the beer."

Around that same time, a change in the state laws regarding breweries enabled them to open off-site taprooms. Jinnett selected a small space downtown, on Second Street between Central and Gold, to create the Blue Corn Microbar. With the Sunshine Theater, a popular music venue, just around the corner, the Microbar began to attract a sizable customer base.

"They were actually showing there just to drink beer. Wow! That was really a revelation. We opened that little place just to help the restaurant, not to make money. It ended up making more money; that little four-hundred-square-foot place, was making way more profit than the restaurant," Gozigian said. "A $3 million restaurant and this little place is making more profit. You can really make a lot of money only selling beer, and you focus on it, and you don't make it an afterthought like it is in a restaurant. Inevitably, if you open a brewery/restaurant, the beer is an afterthought. People are there primarily to eat, and they judge you on that and the service on the food. If the beer is good, that's fine, but that's not what you're known for."

Rice used Microbar as another opportunity to grow the brand and interact with his customers. "I actually bartended down at Microbar when it first opened because I was a head brewer at a brewery, and I was young and enthusiastic and wanted to make more money," he said. "I wasn't the greatest bartender personality. It wasn't necessarily enjoyable, but I wasn't making that much beer at that time."

The Microbar had opened the eyes of the brewery staff. A concept that no one had tried before in Albuquerque, a place with just beer, no frills, no kitchen, nothing beyond a few barstools and tables, was pulling in around $200,000 per year, more than 50 percent of which was pure profit, Gozigian said. An idea was soon born in the minds of Jinnett, Gozigian and Rice to create a brewery just like that.

First, though, they had to save Blue Corn Albuquerque. In 2004, Santa Fe Dining decided to shut it down, revamp and rename it. Chama River Brewing would open in 2005, offering up a more upscale gastropub menu,

moving away from New Mexican food to more traditional American fare, albeit with a high-end twist. The Microbar was rebranded as Chama River as well. It proved to be a major hit. "We enclosed the patio and turned that into a cigar lounge," Rice said. "We added additional fermenters. We expanded the walk-in cooler. We did that, and when we first opened, we probably served under 500 barrels. When I left, on a 5-barrel system, we were doing 1,600 annually. That was because Chama was popular and the Microbar was popular."

Chama River became one of the most popular and successful brewpubs in Albuquerque history. It is still there in that same location, still churning out Rio Chama Amber, Jackalope IPA, Sleeping Dog Stout and more.

Rice, however, had moved on by 2008, along with Jinnett and Gozigian. They had seen the future, and it was not just in the old brewpub or distribution-only brewery models. The Microbar was pointing the way to the future.

"Ten years ago, we had less than a dozen [breweries]. It was definitely a surprise, but the one thing that I can say is that because we were in the business and we did see our craft beer sales increasing. We saw it firsthand, we were already doing it," Gozigian said. "The model wasn't good, but we could see the beer sales going like this [upward]. The proverbial light bulb was that little Microbar on Second and Gold, this little four-hundred-square-foot place that didn't have any food, just one employee—it was just so super simple. If you just sell beer and focus exclusively on that, we can actually make really good money. That was the epiphany."

While they were working on a new plan, however, the rest of the local brewing scene was threatening to collapse all around them.

FALLING DOMINOES

Kellys and Il Vicino had settled into a comfortable routine by the early 2000s. The former relied on its location and spacious patio. The latter was opening new locations for its restaurants, while churning out quality, award-winning beers. The other survivors from the '90s—Assets, Cabezon and Rio Grande—were beginning to struggle for different reasons.

Assets' biggest problem might have simply been a matter of perception. "Assets used to rock because it was a meat market," Cochran said. "People used to go there to hook up all the time. People didn't want to

go there for the beer. At least, I didn't get that sensation that people were there for the beer."

The singles scene, though, was a fickle one and soon moved on to other bars and restaurants in the Northeast Heights. The Southwest Brewing line of packaged beers had failed to take off. Assets had begun contract-brewing the new Isotopes beers, the AAA Blonde and Slammin' Amber, which were created specifically to serve the new AAA baseball team, the Albuquerque Isotopes. The old Albuquerque Dukes franchise had left town after the 2000 season, prompting the City of Albuquerque to tear down the decrepit Albuquerque Sports Stadium located at the corner of University and Avenida Cesar Chavez in the southeast. A new ownership group emerged, buying the struggling Calgary Cannons franchise in Canada and planning to move it to Albuquerque by 2003. A new stadium was built on top of the razed Sports Stadium, and the Isotopes began to play in the Pacific Coast League, becoming an immediate hit. For the most part, though, craft beer was left out of the stadium, and even to this day only a few brands under the control of Admiral Distributing are inside the ballpark.

Jaramillo, sensing that the brewpub was on its last legs, departed in 2003 to take over Blue Corn in Santa Fe, succeeding Cullen Dwyer. By 2005, Assets had closed its doors after nearly thirty years of operation. The Southwest Brewing line was discontinued. The Isotopes beers were still made at the location until 2006, when they were sent to the new brewery built by Sierra Blanca in Moriarty, some thirty miles east of Albuquerque, in a new contract brewing arrangement.

While 2003 marked the beginning of the end of Assets, times were tough over at Cabezon. Owner/brewer Mike Carver was already feeling like he was fighting an uphill battle by the turn of the century. "I was passionate about home brewing and I was passionate about making beer, but I was more passionate about making a business and getting out of Corporate America," Carver said. "The beer was good, but it was going to be a long road to get where I wanted to get. Because I knew my beer was OK, but I didn't think it was great. I felt like I knew what I needed to do to make it great, but it was going to take a while. I got in with a pretty low budget, even though I owned my own building. That was a big part of my business plan."

Carver then seized on another profitable bottling enterprise, one that ultimately pushed beer out the door. "Then New Mexico Beverage had a brand of water they called Santa Fe Springs," Carver said. "They were buying it from Arizona. I said, 'Why don't you let me bottle it.' So then I started bottling water. The first year we bottled water, we bottled

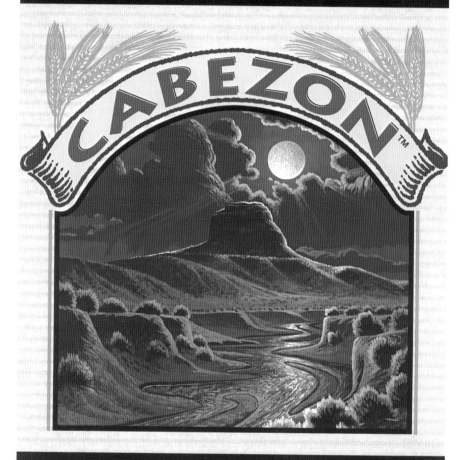

The Cabezon Stout was popular year-round but often faced stiff competition from Guinness every St. Patrick's Day, said owner Mike Carver. *Courtesy of Mike Carver.*

like 30,000 cases. I thought that's a lot of water. The following year, we bottled 250,000 cases. It just happened to be at the right time. It was a money thing, really."

Without the time and space to make the beer, Carver elected to contract-brew his three styles at Rio Grande. "I took the beer across town and had it contract-brewed but pretty much lost interest from that point on," he said. "I sold the brand [in 2004], and that was the end of that story."

Even with the addition of Cabezon's three beers to their inventory, things had been stagnant at Rio Grande. Although Outlaw Lager and Green Chile Cerveza were quite popular, the brewery had never moved to truly seize the market. "I don't want to say anything negative about other breweries, but it didn't work out [with Rio Grande]," Carver said. "The owner [Scott Moore] was kind of really not into it. He liked the fact he didn't have to work very much. It was just keep your volume down. I was to the point where I wouldn't even buy the beer anymore. It was just depressing."

Others had similar observations about Rio Grande. "If Scott Moore at Rio Grande would have actually needed the money and cared, there probably would not be a Marble. He had the market. He had the killer tap handles with the skull on them. He had the Outlaw Lager. He had the marketing. He had everything, but he didn't need the money because his family was rich. He didn't have the 'every day I go to work, I need to do the best I can because this I how I support my family' mentality," Ortiz said. "Rio Grande, they had their handles, not all over the place, but they had their six-packs. They had Albuquerque, it was theirs. They could have expanded, they could have done it, but Scott did not want to do it. That left the door wide open for Marble to come in and be the brand in Albuquerque because they were business-focused."

By 2006, Moore was ready to scale back his role in the business. He decided to join Rich Weber's Sierra Blanca Brewing in building a large production facility in Moriarty. Rio Grande would shut down its brewhouse in Albuquerque, although Tom Hart and the brewing staff would simply work alongside Weber and still produce the Rio Grande beers.

"Space was the issue," Weber said. "'06 was pre-Marble, pre- a lot of people. The thinking was Rio Grande and myself—we had actually talked with Santa Fe [too], but they had already launched their expansion—at that time there's not a ton of volume for everyone. Why don't we put a couple of breweries under one roof? This way we had one equipment bill, one rent bill, and we could be competitive with our pricing and see if we could get our volume up that way."

Even that plan changed just before the facility opened in 2007. "It didn't work out because Rio Grande—about two months into the project, Scott decided he just wanted to get out of the business," Weber said. "Ironically,

he got out of the beer business in '06 and got into real estate, so the exact opposite of what you wanted to do. Real estate crashed in '07, and beer took off. I purchased the Rio Grande brand. Then we redesigned the labels, redesigned the beers completely."

Rio Grande's Outlaw Lager, Pancho Verde Chile Cerveza and Desert Pils are still being brewed in Moriarty and sold around the state. It is the sole remaining legacy of what Moore, Hart and the rest of their team did from 1994 to 2007. "In my opinion, [Moore] lost interest, and the brand was headed downhill," Weber said. "That's why I redesigned the packages with the exception of the Green Chile because I thought that was kind of a fun one with the cow skull and the green chile peppers. I did redesign the beers. The Outlaw, I did our version of a California common. That pilsner was our Sierra Blanca pilsner. It was a tough struggle to convince people. They're doing really well today. The Outlaw is doing really well. The Green Chile, I think, is our number three seller."

By the end of 2007, Albuquerque's brewing scene was down to Chama River, Il Vicino and Kellys, plus the two suburban breweries, Tractor in Los Lunas to the south and Turtle Mountain in Rio Rancho to the northwest. A pessimist would have viewed the future of craft brewing as bleak. An optimist would have viewed it as wide open for a brewery to step in and seize an amazing opportunity.

That brewery was born at the corner of Marble Avenue and First Street in April 2008.

MARBLE BREWERY

The trio of John Gozigian, Jeff Jinnett and Ted Rice had been planning a new brewery for some time. Buoyed by Rice's ongoing success at Chama River as a brewer, and with the Microbar as a model/inspiration, they moved ahead with their plans, targeting an early 2008 opening.

"We took that [Microbar] model forward with Marble Brewery," Gozigian said. "We're not going to do a restaurant. We're going to do a brewery; that's all we're going to do. We're going to be a production brewery, but we're going to have a taproom that's going to pay the rent, essentially. We did some calculations. We don't have to do that much business to break even. We can do whatever, a couple thousand bucks in sales. I think I originally calculated $2,500 a week in sales, and that would cover our original rent, which was

The original brewhouse at Marble Brewery was churning out beer after beer following the opening in April 2008. *Courtesy of John Gozigian.*

$10,000 a month. That will pay the rent, and then we'll start wholesaling and packaging and make a little money with that."

Finding that location was paramount, and in another first that would later be copied by others, an old warehouse became the target. The Starco Industrial Supply Warehouse and Showroom was empty at the corner of Marble and First. Just two blocks north of Lomas and one block west of the train tracks, the building did not immediately scream prime real estate. In a way, though, it was perfect. The warehouse could be converted into a production facility, while the showroom could serve as the taproom that would cover the initial rent. In addition, there were two adjacent parking lots that were purchased. In total, Marble paid $570,000 for the building and the lots. It would cost another $1 million plus to renovate the space, bring everything up to code and install all the brewing equipment.

Marble was still connected to Santa Fe Dining, and Gozigian said that he felt the new brewery could actually help out one of its predecessors. "The original idea behind it was at the Blue Corn in Santa Fe, we were trying to figure out how to enclose our patio to make more dining space," Gozigian said. "It was going to be very expensive. I remember thinking, what if we just took our brewery that's in the back and moved it to a brewery in

Albuquerque. We would use that space as a dining room. Then we can brew here for all of our restaurants out of Marble."

Up in Santa Fe, Brad Kraus, who had been working mainly as a consultant since his Wolf Canyon Brewing went up in smoke in 2000, was called in to oversee the closing of the Blue Corn brewhouse. "2008 rolled around, and they hired me to shut down because they were moving [Daniel Jaramillo] to Marble," Kraus said. "I said it would be a shame to shut down this brewery here. They said they were moving the brewing down to Albuquerque. I told them, 'I give it four months and you'll be calling me back up.' They're like, 'Ha ha, yeah, right.' Then it was four months to the day they called me up and said, 'Brad, we'd like to hire you again to fire this thing up.' When? Tomorrow. I worked at it for a month as a consultant. Then they said they really wanted to hire someone full time. I worked there for three years before moving to Panama."

Kraus's concerns had been relayed to Jinnett, who agreed that Blue Corn should have hung on to the equipment, just in case. "Luckily, Jeff thought ahead," Gozigian said. "He said you know what, let's leave the brewery in place at Blue Corn, just in case. We found the original fifteen-barrel system for Marble in Indiana and brought it back. Sure enough, literally within months of opening Marble, we couldn't keep up with our taproom sales and wholesale sales and do beer for Blue Corn. We had mothballed the brewhouse, and we hired Brad Kraus and started it back up again. It was back up to producing a thousand barrels of beer a year almost immediately."

The grand opening on April 23 featured a line out the door. It blew away everyone's expectations to have a no-frills taproom open north of the main stretch of downtown bars and restaurants and yet become so popular right from the start. "We saw that people were ready for something new," Rice said. "We were packed the first night, just word of mouth, because people were thirsty. Distribution was basically banging on our door; local restaurants wanted to carry our beer. We really didn't have a sales guy in place or a plan or anything. We were just going to open up and have a taproom. Eventually, we were going to do bottles and kegs. Albuquerque just kind of wrapped its arms around us."

In a little over a decade, things had flipped completely as far as distribution. Mike Carver's horror stories of his fight to get Cabezon beers into bars and restaurants were now being replaced by an almost insatiable demand. "What's nice about New Mexico is businesses can have a brewers' license and a distribution license," Rice said. "It's not like Texas. We were fortunate we could self-distribute and sell it to liquor stores and bars. You

could have a taproom whose margins would allow us to thrive and grow and get beer to the public via the distributor format."

That overwhelming demand, besides scuttling the plans to end Blue Corn's brewing days, also forced everyone at Marble to ramp up their plans much faster than they had expected. "I wish I could tell you that we foresaw everything," Gozigian said. "But, no, it definitely blew up beyond our expectations. I remember Brian, the original pub manager at Marble, he was a downtown guy; he was plugged into that scene. He was a bartender at Chama, the Microbar. He told us this place was going to be really busy. I didn't think so, [as] we were pretty far off Central. That area was really decrepit. But we didn't need to do that much business."

That Microbar model was the key. "The Microbar was doing a little over $200,000 a year in sales, which was about 50 percent profit," Gozigian added. "So, we thought, if we can just do as much as that, we'll be totally fine. Within a couple months, instead of $2,000 a week we were doing $20,000 a week in sales. We had bars and restaurants calling us, 'When can we get your beer on tap?' Even Whole Foods, 'When are you going to start packaging?' It was so easy for us. It made us look like heroes. We were all pretty good—Ted was a good brewer, Jeff and I were good businessmen/operations people. We got really lucky with the timing."

There were still people who would walk in the door and need a bit of an education, mainly older customers who remembered all of the brewpubs of the '90s. "I remember when we first opened Marble, it still took quite a bit of time to educate our customers," Gozigian said. "They'd walk in and they were expecting a restaurant. We had a little panini press behind the bar. It was on the menu: 'We are not a restaurant.' From the get-go, we wanted to use like a coffee shop model. You can come in and sit wherever you want. That's why we had the couch and chairs and the patio. We wanted people to think of it as a coffee shop experience. Drink beer at a moderate pace over a long afternoon. It did take some training. A lot of people didn't get it at first. Now, everyone gets it."

Two of Rice's initial beers hit it especially big. His India pale ale and red ale, neither of which had any kind of cute, kitschy names, were flying off the shelves and out of taps around town. "Me understanding the Albuquerque market, I knew that IPA was number one. I always admired Il Vicino's IPA. That was definitely an inspirational flavor," Rice said. "I remember thinking, when I was at Blue Corn, I'm going to be different, I'm going to make an English-style IPA. It was a disaster. People would taste my IPA and say, 'This is weird.' Pale ale was craft's leader in the U.S. for a long time, then it became

IPA. I knew when I opened Marble, because of my experience at Blue Corn and Chama, that IPA was number one in this town. Back then, people in New Mexico were craving big, bold flavors. Why not let them drink beers with that same [big] flavor?"

Marble covered all its bases as far as styles went. In addition to the IPA and red, Rice brewed up Wildflower Wheat, Amber and Pilsner to serve as transitional beers. There was the Oatmeal Stout for dark beer lovers. Specialty runs of seasonal beers soon began, with Imperial Red, Double IPA, Reserve Ale and Imperial Stout becoming so popular they were sold in twenty-two-ounce bottles in addition to appearing on tap at the brewery.

The original, ubiquitous tap handles, solid white with a different-colored marble atop to designate different beers, were soon appearing all across town. Six-packs of bottles were on store shelves everywhere. In one fell swoop, Marble had captured the beer market in Albuquerque. It had created a new model for what a brewery could be, both a production facility like Rio Grande and Cabezon had been but one with a thriving taproom out front, much larger and even more successful than the Microbar. Marble proved that people would come drink quality beer, regardless of whether there was a kitchen in place.

"It was kind of revolutionary," Gozigian said. "Around the country, nobody was doing that. I remember some guys from Arizona, they ended up opening Dragoon Brewing in Tucson, they said they really liked our model. That was really gratifying."

The craft beer revolution had come to New Mexico. Yet no one involved up to that point could have conceived of what was about to happen.

The Rising, 2008–Present

Marble's sudden rise to prominence did not produce an immediate series of clones. It did show, however, that Albuquerque and the rest of the state was ready to embrace local craft beer in a way it never had before. Turtle Mountain's Nico Ortiz said of the late 1990s and early 2000s:

There was not any idea of a statewide beer or the beer of New Mexico. Santa Fe, since '88, they had the logo and the cans, [but] they weren't really aggressive. Neither was Rio Grande. Nobody wanted to be the beer of New Mexico. I don't know if it was just a pain in the ass back then with distribution or what. But you would go to Billy's [Longbar] back then, and you would see a New Mexico handle, a singular New Mexico handle. You had Santa Fe, you had Rio Grande, but I don't think anybody else was bottling at that time. So, literally you had two choices if you wanted like a New Mexico craft beer at the average bar or restaurant. The void was ginormous. In comes Marble and does what needed to be done, and all of a sudden, bam, you have a New Mexico beer. That's why they went from zero to three hundred handles in the course of nothing. The bars were ready.

After Marble's sparkling debut, three different types of breweries would emerge. Some would end up altering their business plans, making changes as they saw fit. For the most part, however, there were facilities like Marble, with a no-frills, beer-only taproom up front and the space for a production facility in the back.

The second type was a new series of brewpubs, sometimes offering up food menus that were off to the side of traditional bar fare. These varied in size, scope and success.

The third type were tiny little breweries that truly earned the term "micro." They would have a half-dozen or so tap handles, sometimes rotating beers out so frequently that there was never anything one could consider a "house beer." In a way, they were nothing more than neighborhood bars with their own beer, a throwback to the many pubs in England and Germany. In a sense, they were the riskiest of models, with limited finances to compete with the much larger breweries that would soon come to dominate the local scene.

Finally, for some of the breweries that had survived from long ago, change was inevitable. It was a new era of adapting to a new craft brew customer, one who wanted a comfortable space in which to enjoy a pint or two and still be able to take his or her favorite ales or lagers home afterward.

THE MICROS THAT FAILED

Not every brewery that opened after Marble enjoyed tremendous success. There were a few that came and went, with their one commonality being their small size.

First up was Hallenbrick Brewery, which opened in 2009. Scott Hollbeck and Jeff Brick opened the small, no-frills taproom at 3817 Hawkins Northeast, nestled in an industrial/business area near the Journal Center business complex. Operating off a tiny brewing system, they generally had one to three of their beers on tap, plus a dozen or so guest taps offering beers from other New Mexico breweries. They had live music on the weekends and served up beers ranging from the altbier to the Adobe Stout.

Hallenbrick's Green Zia IPA came in third at the New Mexico IPA Challenge in 2009. That would be the brief highlight of its run. An ownership dispute had sunk the tiny operation, which was not helped by its location far from any other bars or restaurants, by October 2011. Hallenbrick's closure, though, did not deter others from trying to follow a similar path.

Bad Ass Brewery opened in February 2011 in a shopping center on the southeast corner of Montgomery and Eubank, two major streets in the far Northeast Heights. It was a small, isolated location nowhere near any other

Not every brewery to open after 2008 flourished, as Hallenbrick Brewing came and went in this small space in 2011. *Author's collection.*

existing breweries. It did have several neighbors serving food, plus additional bars in the area.

Owner/brewer Matt Mikesell was a home brewer by trade. He constantly rotated the beers on tap, although it was not always to his own benefit. The Zombie IPA was semi-regular, but others came and went depending on popularity. At one point, a peat-smoked Scotch ale seemed to seep into the entire system, turning every beer a tad more peaty than anyone could want from styles that normally did not have any peat in them.

Eventually, the small brewery struggled to the point that the staff took over from Mikesell, rebranding the brewery as Farside Brew Pub in January 2013. By April, though, they had pulled the plug, shutting the place down for good. The same small space would later host another brewery, Lizard Tail, which would have no relation to Bad Ass/Farside beyond the physical location.

The west side of Albuquerque, meanwhile, had been without a brewery, unless one were to count the places in the suburb of Rio Rancho. That ended in April 2012 when Broken Bottle Brewery opened in a small strip mall along Coors Boulevard, the largest north–south artery west of the Rio Grande, near the intersection with Irving.

Longtime friends Chris Chavez and Donavan Lane had been home brewing for years when they decided to open a home brewing shop. They later discarded that idea and instead decided to open up a small brewery.

Located in a shopping center with a sushi restaurant and a Subway, they focused solely on beers.

Lane handled most of the brewing, while Chavez ran the business. Their beers were a constant rotation of off-the-wall styles. The Incident Black IPA was popular, while others that would come and go frequently included June Bug (summer ale), AFD Red, Mulligan (Irish) Stout, Xico Suave, Wise Ass Watermelon Wheat, Nacho Brau, Rosemary's Baby, Sol Rosenberg Ale, David Hasselheffe, Drunken Hobo Milk Stout and even a Tom Selleck Ale, which for some reason was made with cranberries and seemingly had no ties to the *Magnum, P.I.* star.

"We started out from the beginning wanting to offer unique beers," Lane said after the brewery's first anniversary in 2013. "Even now, when we talk about a new seasonal, we often say, 'That's boring, I want to do something different.' What have we not done? What has no one else done? What is an ingredient we don't see at other breweries?"

Broken Bottle developed a small but strong core group of followers from the area. The beers still earned a lot of mixed reviews. Consistency, a hallmark of larger breweries like Marble, was not something that Broken Bottle could consider a strength. The small brewery did not have the funds to consistently order the same ingredients.

The brewing setup itself was also unconventional. There were plastic fermenting vessels, which were more common in winemaking operations than brewing. It led to more problems than Lane and Chavez likely foresaw. "We get to the point where we've worked through issues, we feel things are consistent and then have this random batch where something goes wrong," Lane said at the end of 2013. "It may be one of your regulars where you've made it twenty, thirty, forty times. You're left picking your brain, trying to figure out what went wrong. Why did it come out different this time? Some of it is just a head scratcher. It's not up to standards, so I'm going to dump it. We had very little of that in 2013. We worked through most of those issues in 2012."

Lane's optimism kept things going. He finished 2013 speaking of plans to move to a larger space, adding more brewing equipment and even teaming up with Mother Road Mobile Canning to begin packaging the beer. Those plans never fully materialized, mainly due to a lack of funding. Things went stagnant for 2014 and continued that way into 2015. Meanwhile, Albuquerque's west side was seeing more breweries open. Marble added a taproom a few miles away. Boxing Bear opened farther north on Coors. An area that had been devoid of craft beer was swimming in it by the summer of 2015.

Broken Bottle announced that it was closing in October 2015. "We opened this place on our own terms, and we will close it on our own terms," Chavez said on the second-to-last night of operation. A small but lively crowd of regulars bid the tiny brewery adieu.

The failures of the post-Marble era, though, were far fewer in number than those that have succeeded up through late 2016. One of the most successful breweries to open was back in 2010, in an industrial area on the east side of town.

La Cumbre Brewing

Jeff Erway was an elementary school music teacher on the Navajo Reservation in northwest New Mexico, a long ways from his hometown of Rochester, New York. He was also a long way from craft beer, which he had developed a taste for during his years at Hobart College.

In the early days of Turtle Mountain in Rio Rancho, Ortiz remembered Erway stopping by with beers he purchased across the state line in Arizona, eager to share them and talk shop with Ortiz and brewer Mark Matheson.

"Erway would come in on a regular basis every week or other week with beers from his travels," Ortiz said. "That's how Erway and I became good friends. On a Friday night, there was a table available, and he would come in with some beers, and I being the MOD (manager on duty) would be able to sit down with him for an hour and taste beers instead of working because there wasn't that much business."

Eventually, Erway started home brewing, earning a number of awards. That, in turn, led him to show up at Chama River and begin working with Ted Rice. Erway headed off to the American Brewers Guild in Vermont to further his education in 2005. After he returned, he became Rice's top assistant at Chama.

When Rice left Chama in 2007 to start the process of getting Marble open, Erway took the reins. He watched from afar as Marble opened and earned immediate acclaim. Erway began to plan his own brewery, looking to go with a similar concept of a no-frills taproom up front and a space large enough in the back to grow into a production facility.

"Luckily, I cut my teeth at Chama River. I can't imagine a better training ground for someone who wants to open a brewery in that they

La Cumbre Brewing owner/brewmaster Jeff Erway (*right*) was all smiles after opening in 2010, with wife Laura and son Miles. *Courtesy of Jeff Erway.*

really make you do all the accounting, they make you do your own inventory, they make you account for all the beer you've sold and your bonuses are dependent upon that," Erway said in a 2012 interview. "So it made me understand that brewing does have to be profitable; if it's not, then what the hell are you doing it for? But it also developed me as a brewer. I wouldn't be able to do what I'm doing today if it wasn't for my time at Chama River and all the help I had from the many brewers that worked above me and under me. I had Ted Rice, who was my first brewer that trained me there…and I learned a lot from Daniel Jaramillo because he would come in there and tell me how bad my beer was all the time, so that was a good thing!"

By 2010, Erway was deep into planning La Cumbre. He chose an empty building at 3313 Girard Boulevard, just north of Candelaria in an otherwise nondescript industrial park, far from Marble but still close to Interstate 25. La Cumbre opened its doors to almost immediate acclaim in December.

That acclaim went national before La Cumbre even celebrated its first anniversary. Elevated IPA beat out more than two hundred competitors to claim the gold medal in the American-Style IPA category at the 2011 Great American Beer Festival in Denver. Elevated was already La Cumbre's best seller, by far, and now the delectable hop bomb had exploded onto the national scene. In addition, La Cumbre earned another gold for BEER (American- or International-Style Pilsner) and a silver for Malpais Stout (Foreign Stout).

With the demand for his beer shooting through the roof, Erway hired Jaramillo away from Marble in the summer of 2012. Erway took the title of brewmaster and handed head brewer to Jaramillo.

"He has skills that are very complementary to my own. Most of the specials we've brewed since he's come on have been collaborations between the two of us. He writes a recipe down, I write a recipe down

and he'll say, 'I don't like that about yours,' and I'll say, 'Well, I don't like that about yours.' We come together and come up with a recipe and it's great, and it always comes out really well," Erway said. "He and I have equally evaluated each other's techniques in the brewery; we've both found out that we're obviously competent in what we do, and we're trying to make everyone in the brewery more competent. He has his way of doing things and I have mine, and we come together and come

La Cumbre's Beer is the simply named and packaged house lager, a gold medal winner at the 2011 Great American Beer Festival and the 2016 World Beer Cup. *Courtesy of La Cumbre Brewing.*

up with ways that hopefully are better for both of us in brewing beer."

Jaramillo's arrival coincided with La Cumbre beginning to mass-distribute its most popular beers in cans. It started with Elevated and then Slice of Hefen. Malpais Stout, BEER and Red Ryeot have since followed.

"Together we've got the quality control of our cans to, I think, be just about as good as anyone could expect of a brewery of our size. Are they what Sierra Nevada's are? No…we don't have a $10 million lab! But, it's been an exceptional fit for both of us," Erway said. "It gives him a brewery that he has a little bit more control over than I think he did down at Marble, because at the end of the day Ted Rice is a full-time brewer… and rightfully so. He wants control over that brewery. I wanted control over my brewery, too, but I wear a lot more hats. So, if I get back in the brewery twenty-five to thirty hours a week, that's a great week for me. I love that. But there are other weeks when I'm lucky to get back there ten to fifteen hours. At the end of the day, Daniel is back there fifty hours a week, and he's controlling what is going on back there, and I think that's good for him and he's happy doing it. It's been great."

By the end of 2012, La Cumbre was producing more than 3,000 barrels of beer in a twelve-month span. By the end of 2016, it came in at 12,700 barrels.

If Marble began to put local craft beer on the map in Albuquerque, La Cumbre showed that it was not a fluke. More and more people began to

plan breweries that would open in the next four years, while for some of the existing breweries, it was time to step up their games if they wanted to compete with the town's new heavyweights.

THE OLD GUARD MAKES ITS MOVE

Three of the breweries in the metro area, all of which dated back to the 1990s, were keenly aware of the boom that was happening with the new kids on the scene. Each of them soon made a move to ensure that it would not be left out.

Sierra Blanca was churning out bottled beers in Moriarty under its own label, as well as those of Rio Grande, but it still lacked any sort of brick-and-mortar presence in Albuquerque. Rather than go it alone, owner/brewer Rich Weber aimed for a cooperative arrangement, much as he had done initially with his current production facility. This time around, Weber found a more reliable partner, teaming up with local restaurant/bar owner Adam Krafft to open the ABQ Brew Pub in 2010. Located near the Louisiana Boulevard exit of Interstate 40, in the shadow of a Marriott Hotel and multiple office buildings, the Brew Pub would exclusively serve the Sierra Blanca and Rio Grande beers, while offering an upscale menu befitting the businessmen and women who inhabited the area by day and the travelers who would appear at night. It was exactly the crowd that Weber wanted to be enjoying his beers. "When Adam and I were working on the Brew Pub, he wanted more of the younger trend, and I was like, you know what, that's great, but we should do that somewhere else," he said. "Where you are is where I'd like to be. Accountants, lawyers, financial guys—that's not a bad clientele."

Years later, when ABP seemed to stall out, the taproom was rebranded as the Alien Brew Pub, taking advantage of the imagery that Weber was already using on his Alien Amber, Alien Stout and Alien Wheat beers. The amber had been his best seller since it debuted in 1997 as a tribute to the fiftieth anniversary of the alleged alien spaceship crash outside Roswell.

Sierra Blanca would also partner with another group to open the Rio Grande Brew Pub and Grill inside the Albuquerque Sunport in 2012. Now even more travelers passing in and out of Albuquerque could taste from the brewery's vast lineup of beers. Weber's moves had been small but strategic, and they kept his brand present in the eyes of Albuquerque beer drinkers who had more and more choices in front of them.

Meanwhile, down in Los Lunas, the new owners of Tractor Brewing were also eyeing the Albuquerque market for expansion. Their first move was to place a taproom in the thriving Nob Hill neighborhood, close to the University of New Mexico, even though the original Il Vicino was across the street and Kellys was a little over a block to the west.

The Tractor taproom opened in July 2011. It shared the no-frills approach of Marble and La Cumbre, offering up just beer in a comfortable setting. The difference was the sheer amount of foot traffic in Nob Hill, as patrons flooded in and out at different times of the day and night. The taproom partnered with neighboring Slice Parlor to have pizzas delivered via a short walk across their shared parking lot. Other restaurants also offered delivery to the taproom. Then along came the food trucks, which had long been shunned in Nob Hill by the many local restaurants. Now they had a place to park and sell their food to legions of beer drinkers who packed Tractor from happy hour until late at night. They would rapidly deplete the brewery's supply of Haymaker Honey Wheat, Farmer's Tan Red Ale, Farmer's Almanac IPA, Double Plow Oatmeal Stout and more.

The taproom's success did not come without some bumps in the road. The biggest was early in 2012, when city officials, responding to a neighbor's complaints, found that Tractor was violating the Nob Hill Sector Redevelopment Plan's ban on packaged liquor sales. The taproom was only filling growlers and kegs, but those were classified the same way as cans and bottles. Almost immediately, Tractor began the process to launch an appeal to have the zoning changed. Luckily for Tractor, it did not encounter much in the way of political or public resistance. Its customers reached out to everyone from the Nob Hill neighborhood association to the city council. After passing through multiple government committees and the like, Tractor received a permit to begin filling growlers again on September 5, 2012.

If that was a challenge, it was nothing like the next big move for Tractor. The brewery in Los Lunas was having more problems than brewer David Hargis could fix. With plans to move back into packaging and distributing Tractor's beers in bottles (and later cans), Hargis and his co-owner, Skye Devore, began to look at Albuquerque for a new brewery site.

They found it in an old cabinet-making factory at 1800 Fourth Street Northwest, along a major north–south artery connecting downtown to the North Valley, while also being conveniently located right off Interstate 40. The eighteen-thousand-square-foot facility would take on equipment new and old, with plenty of room to spare. A taproom would be situated out front, facing Fourth Street. Like its predecessor in Nob Hill, it would only

The massive new brewery space in Albuquerque's Wells Park neighborhood launched Tractor Brewing into the new decade. *Author's collection.*

serve beer, although food trucks would quickly find this new location and park out front seven days a week.

"We kept finding spaces that were big enough but not finished or too close to a school or didn't have high enough ceilings," Devore said in early 2014. "We were starting to think we didn't want to sacrifice what we're looking for in terms of location. We didn't want to be in an industrial strip mall type of place because we saw a lot of spaces like that, and they were great and [had] a great price; we were just worried about [location] because in Nob Hill we get so much foot traffic. Here there's so many little neighborhoods right around here and we're so close to downtown, and [it's] easy getting on and off to the west side [via I-40], we just figured this would be a better location."

The taproom opened to the public on January 31, 2014. The brewery was soon up and running, and Tractor quickly solidified its position in Albuquerque. Music acts were soon booking the interior stage. Slam poetry

Tractor Brewing is one of several with women in key positions, including taproom manager Melissa Martinez (*left*), office manager Nicole Duke and co-owner Skye Devore (*right*), who posed with Devore's twin daughters. *Author's collection.*

contests were also on the docket, as were live art shows, charitable events and much more. A brewery taproom quickly became a center for arts and culture, just as Marble was doing closer to downtown. In an era when artists and musicians had seen the number of available venues begin to shrink, suddenly the breweries were providing a new outlet for their talents.

"Tractor for me, from the outside looking in, they were always a supporter of the arts—a supporter of theater, of art in general and not just music—and then this space has really lent them the space to show that, not just to like support it from being the sponsor of events and off-site serving at events but to bring in those events here," said Carlos Contreras, the brewer's former events coordinator.

Tractor had found its niche with a blend of beer mixed with an atmosphere of arts, entertainment and a general sense of fun.

Meanwhile, over on Vassar, the folks running Il Vicino were already running into the dreaded dual problem of a lack of space and the need for a more beer-centric location to show off the talents of brewers Brady McKeown and Doug Cochran. They did not look far, selecting an empty building at the corner of Aztec and Stanford not too far south of their previous location and around the corner from La Cumbre.

The Il Vicino Canteen opened in the summer of 2011, offering up house beers like Wet Mountain IPA, Slow Down Brown, Dougie Style Amber

(yes, named for Cochran), Dark & Lusty Stout and Pigtail Pilsner, plus a slew of rotating taps for seasonal and specialty beers. From heavy hitters like St. Bob's Imperial Stout and Exodus IPA to the lighter Irish Red and Boysenberry Wheat, the Canteen was jumping. Blessed with a spacious, partially covered patio area and a general atmosphere of kicking back with a pint or two, the Canteen soon solidified its own niche. Offering up a limited menu of sandwiches and finger foods, with just a pair of TVs above the bar for the scattered sports fans, plus a small stage for musicians on the weekend, Canteen was able to thrive even with La Cumbre down the street.

After celebrating its twentieth anniversary in 2014, the decision came to rebrand the brewery as Canteen Brewhouse, in effect separating it from the Il Vicino restaurant chain. Canteen would still brew for the restaurants, but now it could also make the move to begin packaging and wider distribution without running afoul of conflicting state licenses for restaurants and wholesalers.

"Most people know us because we've been here for so long," Cochran said at the end of 2014. "It's just same place, different name. But all the branding with the shirts and that stuff—that was tough. We had to redo all our growlers, T-shirts, glassware, coasters."

Canteen replaced its original seven-barrel brewhouse with a new fifteen-barrel system in 2015. Exodus IPA and Dougie Style Amber would eventually appear in six-pack cans around town.

Things were looking up, even for the old guard. That was good, as the trickle of new breweries was set to become a flood.

Nexus Brewery and the New Brewpub Revolution

Even with the success of Marble's and La Cumbre's no-frills, beer-only taprooms, the concept of the brewpub was not dead in 2011. It was mostly dormant, but almost by accident, it came roaring back.

Ken Carson did not set out to open a brewpub along the northbound frontage road of Interstate 25, but that is what ultimately happened with Nexus Brewery. Carson, a banker, saw the economic crash of 2008 and began to think of a new line of work. "I said I'm going to invest the money in creating a business," he said in 2012. "One of the businesses I visited a lot was Marble Brewery when they first opened. I watched them grow and accelerate."

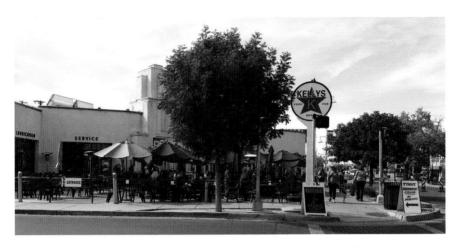

After moving to this location in 2000, the Kellys patio has become one of the most popular destinations for locals and tourists in Nob Hill. *Author's collection.*

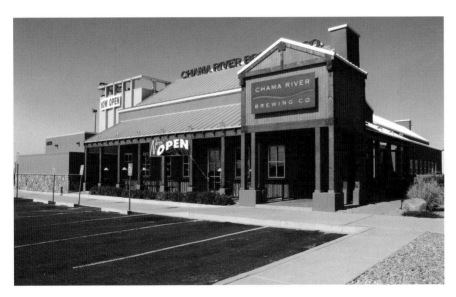

Blue Corn was renovated and renamed Chama River Brewing Company in 2005. *Courtesy of John Gozigian.*

Sierra Blanca Brewing in Moriarty, east of Albuquerque, ultimately absorbed the defunct Rio Grande Brewing in 2007. *Author's collection.*

The four-man ownership team of Bosque Brewing. *From left to right*: Jared Michnovicz, Gabe Jensen, Jotham Michnovicz and Kevin Jameson. *Author's collection.*

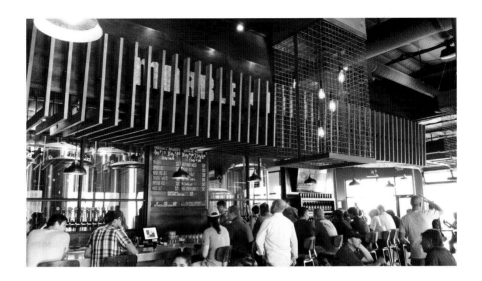

Above: Marble Brewery continued to expand across the metro area with the opening of its Northeast Heights taproom in 2016. *Author's collection.*

Left: Cazuela's, a Mexican restaurant in Rio Rancho, began brewing its own beer in 2012. *Author's collection.*

Bosque Brewing owners Jotham Michnovicz (*left*), Gabe Jensen (*center*) and head brewer John Bullard hoist the NMIPA Challenge trophy after their victory in 2015. *Author's collection.*

Left: Bosque Brewing brought home its first gold medal from the Great American Beer Festival in 2015 for the Acequia IPA. *Author's collection.*

Below: Albuquerque brewers Kaylynn McKnight of Nexus (*left*), Justin Hamilton of Boxing Bear (*center*) and Jeff Erway of La Cumbre brought home gold medals from the World Beer Cup, although Jeff left his in the office. *Author's collection.*

A dozen local brewers gathered at Chama River Brewing in 2015 to create the 505 Collaboration Beer for ABQ Beer Week. *Author's collection.*

Left: New Mexico Brewers Guild executive director John Gozigian was all smiles after taking the job in January 2016. *Author's collection.*

Below: Beer geeks assemble annually at the state fairgrounds for the New Mexico Brew Fest, held every autumn. *Author's collection.*

Above: Fans gathered on the opening night at Dialogue Brewing, one of two breweries to open in the fall of 2016. *Author's collection.*

Right: Items and apparel with the original Glorieta Beer logo were popular in Albuquerque in the early 2000s. *Courtesy of Adam Galarneau.*

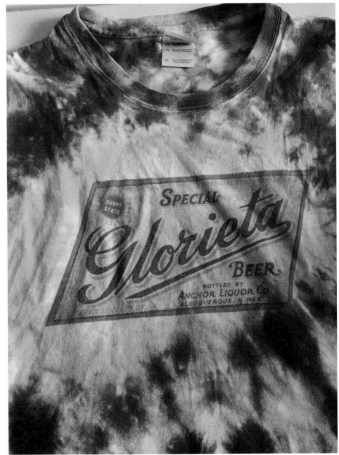

Beer hunter Michael Jackson (*right*) was more excited than he looks to visit brewer Mark Matheson at Assets Grille and Brewery in the mid-1990s. *Courtesy of Mark Matheson.*

Every available bit of space at Assets was used to keep the beer flowing during its heyday. *Courtesy of Mark Matheson.*

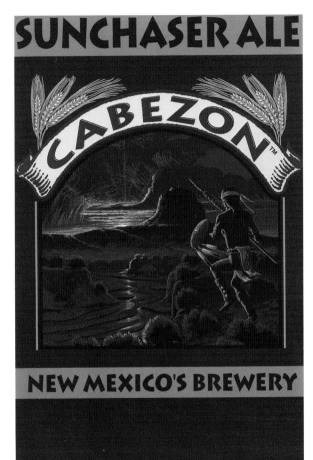

Right: The Sunchaser was one of three beers bottled at Cabezon, and its name was later reused by Sierra Blanca Brewing. *Courtesy of Mike Carver.*

Below: Current Canteen Brewhouse brewers Doug Cochran (*left*) and Zach Guilmette are the men in charge of Albuquerque's oldest brewery. *Author's collection.*

The remodeled private dining room at Chama River looks into the brewing space. *Courtesy of John Gozigian.*

Then head brewer Jeff Erway, as Dr. Strange Hop, and his wife, Laura, celebrate Halloween at Chama River in 2008. *Courtesy of John Gozigian.*

Marble Brewery in 2016, with the current logo, plus the stage area replacing a small parking area, the now covered patio, rooftop deck and the towering fermentation hall in the back. *Courtesy of Mario Caldwell.*

La Cumbre brewers Jeff Erway (*left*) and Daniel Jaramillo flank Brad Kraus, former head brewer at Rio Bravo, Wolf Canyon and Blue Corn. *Courtesy of Daniel Jaramillo.*

Beer lovers gathered for the final round of the 2015 New Mexico IPA Challenge at Boxing Bear Brewing. *Author's collection.*

Members of the Dark Side Brew Crew gathered at the 2015 New Mexico IPA Challenge at Boxing Bear. *Author's collection.*

Marble brewmaster Josh Trujillo enjoys his hard work. *Courtesy of Mario Caldwell.*

Marble switched from bottles to cans for its popular Red Ale in early 2016. *Courtesy of Mario Caldwell.*

A flight of sample beers, including multiple sour ales, at Pi Brewing. *Author's collection.*

The general public gathered in droves for the grand opening of Palmer Brewery. *Author's collection.*

Opposite, bottom: Quarter Celtic added a "crowler" machine, featuring reusable thirty-two-ounce aluminum cans, for customers to take its beer home. *Courtesy of Quarter Celtic Brewpub.*

Elevated IPA has been La Cumbre's best-selling beer since the day it opened in December 2010. *Courtesy of La Cumbre Brewing.*

Farmer's Tan Red Ale was one of the first Tractor beers to be canned, featuring artwork from local artist David Santiago. *Courtesy of Tractor Brewing.*

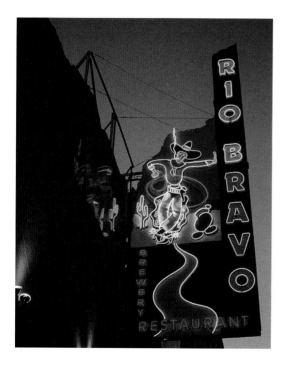

When Rio Bravo opened downtown in 1993, it made use of an existing neon cowboy sign on the building. *Courtesy of Stan Hieronymus.*

With Marble on his mind, Carson pushed ahead with plans to open his own brewery by May 2011. A lifelong *Star Trek* fan, Carson went with Nexus as the name, later adding the paraphrased line, "Drink craft beer and prosper" above the bar.

Carson said that he wanted beer to be the primary focus, but after looking at the other newer breweries' taprooms, he decided that a full kitchen was a better idea than a limited food operation. Nexus had a small parking lot, tucked away in a small business complex just north of the Montgomery Boulevard exit, so putting food trucks out front seemed impractical. By the end of 2012, Nexus's first full year of operation, the brewery had found itself in full brewpub mode, with the food outselling the beer.

"We expanded the [kitchen] area and doubled it," Carson said. "My budget was written with us expecting it to be 20 percent of the sales for food. That's as high as I ever expected it to get. Within three months, it was already going to 40 percent. Right now, we're sitting around 60 percent. We haven't lost any [money] on the beer, either. The beer is going up, too, but it's not going up as rapidly as the food is. We're appealing to people that aren't necessarily beer drinkers."

Carson initially wanted a barbecue-dominated menu but discarded that idea, calling it a "low-margin, high-loss" style of food. Instead, he noticed that Albuquerque was lacking a place that served traditional, southern-style soul food. Menu dishes like chicken and waffles soon became hugely popular, although in many cases, Nexus's kitchen staff added some New Mexico touches—putting green chile in the mac and cheese, for instance. Soon, Nexus was jammed full of people, hungry for food that was different and also high quality.

Nexus Brewery has become one of the most popular restaurants in Albuquerque thanks to its unique menu, including the popular chicken and waffles. *Author's collection.*

As for the beer, founding brewer Manuel Mussen, a graduate of the University of California–Davis brewing program, followed Carson's desire to have more malt-forward beers rather than the hoppy IPAs that were dominating the local market. The brewery's Scottish Ale and Cream Ale became popular, along with the Imperial Cream Ale.

Nexus found itself getting national attention in 2013 when celebrity chef Guy Fieri brought his Food Network show *Diners, Drive-Ins and Dives* to Nexus for an episode. Carson aimed to ride that momentum and open a second location in 2014 but ultimately delayed that move until 2016, when Nexus Silver finally opened on Albuquerque's west side, near Coors Boulevard and Interstate 40.

Meanwhile, by early 2014, Mussen was ready to return to his home state of California, leaving Nexus in hiring mode for a new brewer. Carson did not look far, heading over to La Cumbre to hire assistant brewer Kaylynn McKnight, who would become the second female head brewer in modern New Mexico history.

McKnight was a server at Chama River who had expressed interest in learning the brewery side to Erway when he was still running the show there. After La Cumbre opened, she applied to join the staff. "Well, when I applied [in 2011], I wrote down 'bartender/assistant brewer,' almost half-jokingly. I'd been harassing him for four years, and he kind of laughed at me every time. He sat me down for the interview in his office and pretty much told me that I was hired as a bartender and finished up the interview," McKnight said in 2014. "Then he turned it around on me and said, 'Well, for the brewing you'll need some steel-toed boots. You're going to have to wear long pants. You're going to have be here early in the morning. You're going to start one day a week, and we'll see if you do well, then we'll bump you up to two days a week, three days a week, so on and so forth.' He gave me the chance as soon as I got hired there, [but] I think he was still a little skeptical."

McKnight earned her place at La Cumbre, working alongside Erway and learning from him and Jaramillo until she transferred to Nexus in March 2014. She would go on to win multiple awards for her Honey Chamomile Wheat, while continuing to push Nexus's beers to the same level as the food.

Elsewhere around town, two other brewpubs would take flight in 2012 and 2013, albeit at radically different levels. Sandia Chile Grill harkened back to the old days, when an existing restaurant would add a small brewing system. Located in the Del Norte Shopping Center at San

Kaylynn McKnight, the second female head brewer in modern New Mexico brewing history, stands atop her brewhouse at Nexus Brewery. *Author's collection.*

Antonio and Wyoming, the same place where Bavarian Lager Cellar and Dry Gulch once operated, the small New Mexican restaurant squeezed in a tiny system and began to produce beers like Rattlesnake IPA, Rio Negro Milk Stout and Barb's Barrel Hefeweizen in July 2012. The father-and-son team of Mick and Clint Coker ran the operation, with Clint having won awards for his ciders and meads in local home brewing competitions.

With a low overhead and a strong customer base from their years of serving food, the Cokers were able to succeed at Sandia Chile Grill, which was still humming along at the end of 2016. The same could not be said of the comparatively enormous and ambitious project that had popped up on Albuquerque's west side in late 2013. The Stumbling Steer, envisioned as a high-end gastropub, was set to move into the old Quarters restaurant space at 3700 Ellison Road. A consortium of owners, both local and out of state, was bringing some considerable financial might to bear. It hired Kirk Roberts as brewmaster, bringing fifteen years of experience at Newport Beach Brewing and San Diego Beer Company to Albuquerque. The owners purchased a twenty-barrel brewhouse from a Gordon Biersch in Miami.

"We're targeting opening the restaurant beginning of December and the brewery—that's about when we're getting the equipment," Roberts said in October 2013. "The brewery is not going to be quite ready yet. [The government shutdown] definitely didn't help. So, we're really close to getting our TTB approval."

The problem that the Steer would eventually encounter would be the fact that it never got the actual brewery up and running. Roberts's beer recipes were contract-brewed out at Sierra Blanca in Moriarty. He did a few special small batches and a number of variants, on cask and through a Randall, at the brewpub, but otherwise Roberts never ended up brewing on site. Even with a strong food menu, the amount of money poured into the physical structure of the space had drained the Steer of its available funds.

Cracks began to show midway through the Steer's first year of operation in 2014. The head chef departed abruptly, weakening the quality of the food. General manager Sonny Jensen departed not long afterward. By early 2015, Roberts quietly walked away after his brewery was never put into operation. The brewpub shut down for good on May 1, 2015.

Much like the smaller breweries that came and went, the Steer was a cautionary tale, one on the opposite end of the spectrum. It opened big and aimed high but ultimately proved to be an unsustainable concept. Albuquerque's west side is dominated, in a demographic sense, by young families. The Steer's food prices were higher than they would normally pay. That, plus the lack of the actual brewery part of the brewpub, conspired to sink the entire operation.

Other breweries and brewpubs, however, would continue to surge into the metro area.

BOSQUE BREWING

The background story of Bosque Brewing reads like numerous others. A few friends who liked to brew at home got together and decided to open their own small brewery. Places like that had come and gone in the past, or simply ended up limping along, never really catching fire without some key ingredient, be it capital, business savvy, brewing experience or a combination of two or more of those.

Right away, it became apparent that the quartet of Kevin Jameson, Gabe Jensen and brothers Jared and Jotham Michnovicz certainly had the

business part down pat. "We're all entrepreneurs," Jameson said before the brewery opened in October 2012. "And so we had to do something. There's no way we could have not tried some kind of business. We just read everything we could, we read every book, every blog [and] site out there. From the business side, we had to get going. So, we bought a pilot system, the same pilot system that Stone and New Belgium use. We got some recipes going. There's only so long that the wives will let you do a really expensive hobby."

Jensen was initially the man in charge of brewing when Bosque opened at 8900 San Mateo, just north of Alameda near Interstate 25, inside a nondescript strip mall that also housed a Subway and a few small businesses. Bosque had a small menu of appetizers and sandwiches, but for the most part, it was focused on brewing up popular beers such as its Scotia Scotch Ale. Many of the other initial beers, from Cumulus Wheat IPA to Olde Bosky Porter, were eventually moved from regular status to seasonal. Riverwalker IPA, Driftwood Oatmeal Stout and many others would soon take their spots as year-round offerings.

Bosque managed to not just survive but thrive in 2013, its first full year of operation. By early 2014, it had some major moves in the works. Plans were afoot for not one but two new taprooms, one in Las Cruces and the other in Nob Hill. The most important move, however, came when Bosque announced that it was hiring a new head brewer.

John Bullard had gotten into brewing in the early 2000s. A native of the small town of Edgewood, east of Albuquerque, Bullard worked as a delivery driver for Marble, then as a cellarman and finally as an assistant brewer. He hopped around between Marble, Chama River and Blue Corn, working with the likes of Ted Rice, Daniel Jaramillo, Jeff Erway and even Brad Kraus.

"I had John Bullard working with me there for a while [at Blue Corn]," Kraus said. "He's gone on to become just a fantastic brewer as well."

After a stint at the American Brewers Guild, Bullard was eventually promoted to head brewer at Blue Corn after Kraus's departure in 2011. Bullard would go on to win two silver medals for Blue Corn at the 2013 Great American Beer Festival. Those followed his upset victory in the 2013 New Mexico IPA Challenge, where Bullard became the first brewer outside Albuquerque to ever claim the coveted trophy.

"It feels great," Bullard said in 2013. "So many people think you've got to be a giant brewery to make good beer. There are so many people opening up small breweries, and we're making fantastic beers. Don't underestimate the small breweries."

Head brewer John Bullard took over operations at Bosque Brewing in 2014 after winning multiple medals at Blue Corn in Santa Fe. *Author's collection.*

The Bosque ownership had its eye on Bullard even before his 2013 accomplishments. Jotham Michnovicz said by late 2013/early 2014 that Bosque had to make its move before someone else snatched him up. "I think as we were poised for growth as Bosque, we knew we were going to need more team members," Michnovicz said. "John had caught our attention a long time ago. Then he started winning a bunch of awards and started getting everyone's attention. We'd kind of been kicking around the idea of what was the next move for Bosque. When we were talking about it together, it all made sense. We needed to bring on more brewing staff anyway because of what's going to go on. Having someone who can run the ship back there is a big deal for us."

Bullard was similarly impressed with what Bosque had done up to that point, as well as with its business plan for the future. "First was their branding, their marketing, all their logos, everything about it was just awesome, really strong," he said. "[They were] straightforward—that was the first thing that caught my attention. Their beer did, also, because honestly I was worried when I read their story. I was like, 'Oh, man, here we go.' But you guys have really impressed me."

 CROWN
Brand-Building Packaging™

12oz Beverage Can Template

The label for Bosque Lager was recently updated to include its silver medal at the 2016 Great American Beer Festival. *Courtesy of Bosque Brewing.*

Bullard officially joined Bosque on March 10, 2014. The brewery took off from there in terms of popularity, quality and overall production. Bullard would go on to claim back-to-back New Mexico IPA Challenge titles in 2014 and 2015, while also adding National IPA Challenge victories in 2015 and 2016, becoming the first brewery to ever repeat as champion. Medals at the Great American Beer Festival and World Beer Cup would follow, all while Bosque opened those two additional taprooms, with Las Cruces becoming especially popular.

"We increased draft distribution by 250 percent [in 2015]," Jensen said. "We increased staff from about twelve people on payroll to fifty on payroll and spent the rest of the year dealing with that. Learning how to run a machine instead of a nice mom and pop brewpub that we had. I think we finally hit our stride [knocks on wood]; I think the taprooms are running smoothly now and found their place in their respective markets. Now we're ready to do it again."

By early 2016, Bosque had announced plans to build a sizable production facility inside the old Jackalope building in Bernalillo along Highway 550,

just west of the Rio Grande. It would include a taproom as well. "The brewery will allow us to [eventually] do up to thirty thousand barrels a year," Jensen said. "That's not our goal in 2017 or anything like that. We did four thousand barrels last year and we're on pace for five thousand, but we are getting some more fermenters [at San Mateo]. Hopefully, by summer we'll be on pace for seven thousand or eight thousand over a twelve-month period. Coming in here we should be able to do fifteen thousand barrels. What that's going to allow us to do is package."

After renovations to the building were delayed in 2016 due to construction on the highway, Bosque opted to get its three core beers into cans via contract brewing in Colorado. Six-packs of Bosque IPA (the renamed Riverwalker), Bosque Lager and Scotia began to arrive in Albuquerque liquor stores in late October, just a few weeks after Bosque won two more medals at GABF and finished third at the Alpha King Challenge for its Moon Cannon Double IPA.

In four years, Bosque had gone from a tiny strip mall brewery to a major player in the local beer scene. In those same four years, things had gotten awfully crowded in Albuquerque.

THE SURGE OF 2014

Two existing restaurants would add brewing operations, and three new breweries would open in 2014. Between their varied locations and differing philosophies, each brought something new to the local scene.

Bistronomy B2B was a small restaurant located in Nob Hill, just a few blocks west of Kellys Brew Pub. It began brewing small batches of beer to go with its selection of gourmet hamburgers and other dishes. The Coconut Porter was one of the only beers that constantly remained on tap. Otherwise, it was a continual rotation of traditional and experimental styles. The owners of B2B opened a larger taproom, Lobo Beast 101, farther west on Central, across the street from the university. Another B2B would open along Louisiana Boulevard in the Uptown area. It focused on New Mexican–themed food instead of hamburgers, while offering up a selection of house beers and guest taps.

Nicky V's Pizzeria was a popular restaurant on the west side, located at 9780 Coors Northwest, just north of the traffic light at Irving and what was Broken Bottle, albeit on the east side of the busy street. The restaurant was operated by the husband-and-wife team of Greg and Nicole Villareal. It

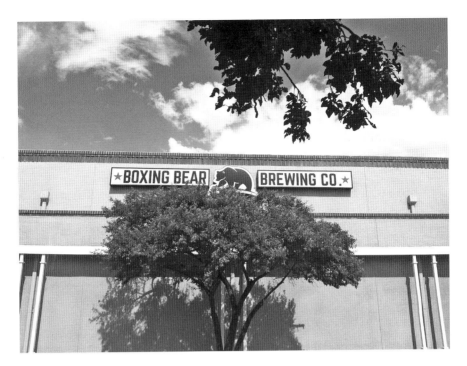

Boxing Bear opened to rave reviews on Albuquerque's west side in 2014. *Author's collection.*

was Greg, along with his friend, Charlie Sandoval, an accomplished home brewer, who decided to add a brewing element to the restaurant. They put the brewhouse and equipment inside an empty storefront next to the restaurant and called it Pi Brewing.

Plans to have a separate, beer-only taproom inside the brewery were scuttled by logistics, namely that to reach the bathroom in the back, one had to walk through the brewing area, which was not allowed by the city health department. Instead, the brewery's beers were sold almost exclusively at the restaurant. That, in turn, led to the decision to simply rebrand the entire restaurant as Pi Brewing in January 2016.

Greg Villareal took over all the brewing operations in 2016 as Sandoval retired. Villareal instituted a sour ale program, while continuing to produce popular beers such as U Down w/ BVP? (Bourbon Vanilla Porter), Cardinal Sin Red Ale, Discordia IPA, Scotty Doesn't Know and Preacher's Daughter Red Ale, a chile-infused beer named after Albuquerque boxer/MMA fighter Holly Holm.

Just a few miles to the north of Pi, a new partnership had come about to create an impactful, full-scale brewery for the west side. Kevin Davis and

David Kim, who were behind the successful Southwest Grape and Grain store, and Justin Hamilton, the head brewer at Chama River, teamed up to start Boxing Bear Brewing. They took over the former Elliott's Bar, located in a shopping center on the northeast corner of the intersection of Alameda and Coors/Corrales Boulevard, just west of the Rio Grande. After a massive renovation to install a brewery and turn the old bar area into a taproom, Boxing Bear opened its doors in September 2014.

"And then, you know, the next couple weeks after that were pure madness," Hamilton said at the end of the year. "Luckily, we were able to get a hold of our serving needs and our ability to take care of our patio and our pub at the same time. After that, things started running a lot smoother. We started to see a lot more regulars and people coming in here every day to just enjoy our place and our beer."

Hamilton's beers, paired with a limited menu of sandwiches made behind the bar, began to take off right away. Every beer received a boxing- or bear-themed name, from Uppercut IPA to Standing 8 Stout, Paw Swipe Pale Ale and AmBear Amber Ale. The brewery also hit it big with seasonals like the Chocolate Milk Stout and Sucker Punch Double IPA. Limited bottling runs soon brought Boxing Bear's beers to the east side of town, while the brewery also began filling kegs for distribution to local bars and restaurants.

The Chocolate Milk Stout earned Boxing Bear a silver medal at the 2015 Great American Beer Festival and then a gold at the 2016 World Beer Cup in April. Hamilton snagged the coveted New Mexico IPA Challenge trophy in July, just edging out Canteen in the closest final vote in the event's history. Boxing Bear would then claim two gold medals for Chocolate Milk Stout and the Red Glove, a double red ale, at the 2016 Great American Beer Festival, where it was also named the Mid-Size Brewpub of the Year. "To be the second brewery in New Mexico to pull off a brewery of the year [award], and it's only in our second year, we're super proud," Hamilton said, referring to Marble winning Small Brewery of the Year in 2014. "We couldn't be any happier."

Over on the other side of Albuquerque, Lizard Tail Brewing opened in the Northeast Heights in August 2014, taking over the space formerly occupied by Bad Ass/Farside in a shopping center at the intersection of Montgomery and Eubank. Longtime friends Ken Rhoades and Dan Berry teamed up to start their own small, no-frills brewery taproom. They removed almost every trace of the preceding breweries, including disposing of any leftover equipment in the back.

Berry, who had graduated from the American Brewers Guild, had been home brewing for years. He then persuaded Rhoades to join him, first

brewing in Rhoades's house and then moving to open their own place. Armed with a tip from a friend at Southwest Grape and Grain, a local home brew store, the duo checked out the empty space and decided to go for it. "Basically, it was Kevin [Davis] over at Grape and Grain one day when I went over there," Berry said. "He just told me the space was open. I'd actually been in here a couple times before. I liked the location. I figured just put a lot of money into the brewery and the location would do the rest, hopefully."

Eventually, the small taproom began to take off, as predicted. Many of the beers were given lizard-themed names, such as the Horned Honey Pale Ale, Reptilian IPA, Basilisk Brown, Bluetail Blonde and Chuckwalla Abbey.

With a Marble taproom moving in just up Montgomery later in 2016, Berry spoke of moving to a different, larger space in the area to brew more beer, but as of October, that move had yet to come to any sort of fruition.

The Stumbling Steer may have been the first brewery to have out-of-state owners, but it was not the last. Ponderosa Brewing would open in September 2014, owned in totality by the same people behind PINTS Brewery in Portland, Oregon. Those owners already had purchased mix-used property in Albuquerque, an apartment complex with retail space on the bottom floor located at 1761 Bellamah Northwest, just up the road from the New Mexico Museum of Natural History and within walking distance of Old Town. Seeking an anchor tenant, the PINTS owners decided to open a new brewery. Brewmaster Alan Taylor dispatched one of his assistants, Matt Kollaja, to open Ponderosa.

Ponderosa was done in the brewpub style, with a full kitchen and a sizable dining area, including an outdoor patio on the north side of the building. With

Ponderosa Brewing began limited runs of twenty-two-ounce bottles for two of its beers in 2016. *Courtesy of Ponderosa Brewing.*

Hotel Albuquerque to the west and Old Town and the museums to the south, it drew a mixed crowd of local residents and tourists from across the country. Kollaja followed Taylor's recipes, introducing Albuquerque's beer drinkers to Rip Saw Red, Ghost Train IPA, Crosscut Kolsch and Sawmill Stout. All were named after the local Sawmill neighborhood, a former lumberyard area that served the rail lines in the early 1900s.

The biggest problem Ponderosa has encountered has been keeping its brewers. It is one thing for a head brewer to have a brewmaster above him—at least in those cases they are often side by side at the brewhouse or at least within the same building. Having Taylor oversee things from two thousand miles away in Portland has proven difficult. Kollaja departed for a job back in Oregon in May 2015, replaced by Andrew Krosche, who had worked for several years at Marble. Krosche, in turn, left at the end of the year to take over the head brewer position at Chama River. Bob Haggerty, formerly of La Cumbre, took the reins to start 2016. By summertime, Haggerty had resigned to begin the process of planning out the forthcoming Steel Bender Brewyard. Antonio Fernandez, a local home brewer and former sous chef, was brought on as the brewery's fourth head brewer in two years.

Just as Ponderosa was opening closer to downtown, another brewery sprang up in September 2014 closer to the industrial area that housed La Cumbre and Canteen. Red Door Brewing joined the local scene at 1001 Candelaria Northeast, just west of Interstate 25. Similar to Bosque, the brewery was the creation of a group of friends and business partners. Matt Biggs would serve as business manager, with Jeff Hart as sales manager, Frank Holloway as taproom manager, Wayne Martinez as brewmaster and Rob Stroud as head brewer.

"I've known Matt for years," Martinez said in 2014. "I got into home brewing, like most people, maybe four or five years ago. I started taking it really seriously, built a [home brew] system, got really into that. That's when I realized I didn't want to do my job anymore. So, I quit, got a job serving at Marble on the west side, then got into the back [at Marble downtown]."

Holloway and Biggs, right after the latter's wedding, then began the process of planning out their own brewery. Months later, armed with a fifteen-barrel brewhouse purchased from COOP Ale Works in Oklahoma City, Red Door took over an empty warehouse and got to work. The brewery opened in September with a sizable taproom and a handful of beers on tap. The Threshold IPA, Roamer Red and Paint It Black Milk Stout, served on nitro, have become the brewery's staples, along with

Unhinged Cider. Red Door later became the first Albuquerque brewery to regularly offer up gluten-removed versions of its beers.

Red Door would go on to add a taproom in downtown Albuquerque in 2016, while also distributing beers via keg sales throughout the metro area.

THE SURGE OF 2015

Albuquerque's beer-drinking population barely had any time to catch its collective breath after the multiple openings of 2014. Four more breweries, one large and three small, would open in 2015.

Albuquerque Brewing joined the fray in March, opening at 8610 Pan American Freeway. Located off the northbound Interstate 25 frontage road roughly halfway between the Paseo Del Norte and Alameda exits, the brewery and taproom were placed inside a former showroom for the granite tile business that occupied the rest of the building. Mike Marsh, a longtime home brewer, was hired to run the operation, which was controlled by a varied group of investors including Curt Richter, whose father owned the adjacent United Stoneworks.

It was not an easy first year for Albuquerque Brewing. The city shut the place down after an inspection revealed that drainage in the brewhouse area was not sufficient. By September, a dispute between Marsh and the owners had led to his dismissal as head brewer. "It was a couple of different things," Marsh said. "We got a board of directors together. The board of directors decided I wasn't producing enough beer. The board of directors also decided they didn't want to pay me anymore. That's pretty much how it happened."

John "Carnie" Bevz, a former assistant brewer at Santa Fe Brewing, was hired to take over later in 2016. Bevz was able to streamline the operation as best he could, settling on a group of core beers—High Plains Draft Blonde, Duke's Pale Ale, Off the Richter Imperial Red, Dunkelweizen—while featuring one rotating seasonal and a special nitro tap. The brewery also added a pizza oven, while booking plenty of live music and other shows for its spacious patio. As we start 2017, however, Albuquerque Brewing is closed, possibly for good, and locked in a legal battle between Marsh's faction and the remaining owners, including Bevz.

Over in the industrial area near La Cumbre, which by this point had been officially named the Brewery District by the state legislature, a new type of operation sprang up. Craft distilling had just arrived in New Mexico, but

so far, these distilleries were focused solely on hard liquor. Distillery 365 decided to go with a dual approach, producing both spirits and a limited number of beers. Founded by longtime friends Matt Simonds and Matt Bishop, the combo facility opened in a small warehouse space at 2921 Stanford Northeast, just south of Candelaria, in April.

"The one thing we started to realize real quick was that we're going to get all this distillation equipment, and we're like, 'OK, we've got a cash-flow problem because you can't sell bourbon until it's been aging for a while; what are we going to do to stay afloat?'" Simonds said. "We've got all the brewing equipment. There's 90 percent overlap. Why not do some beer as well? So, we decided to do dual-licensing. We're licensed as a distillery and a brewery. We thought what better way to round out your product offering than to have a place where you can come in and have a couple beers or a couple drinks?"

Offering up relatively simple beers like Otero ESB, Lone Pine Pilsner and Sancho Saison alongside their many spirits, Distillery 365 enjoyed enough success to eventually add a small tasting room (liquor only) at the Green Jeans Farmery complex of shops and restaurants near Carlisle and Interstate 40. The only significant change came when Simonds and Bishop were forced to change the name to Broken Trail Brewery and Distillery after a case of copyright infringement with the 365 product line at Whole Foods was brought to their attention. Otherwise, the brewery/distillery combination was proving to be a success by the end of 2016.

The heart of downtown, in the meantime, was still without a dedicated brewery in 2015. Ever since Rio Bravo and San Ysidro closed in 1998, the area close to Central Avenue was devoid of beer brewed on site. Part of that had to do with zoning, as the city had elected to block beer production along Central downtown in order to help clean up and revitalize the area. (Marble was located two blocks north of the no-beer zone.) By 2015, though, craft breweries were seen in a different light, leading the city to amend its zoning laws to allow beer production to resume downtown. The first brewery to benefit from this was Boese Brothers Brewery, located on the northwest corner of Sixth Street and Gold Avenue.

Owned and operated by two actual brothers, George and Sam Boese, the new brewery took over a historic building that had most recently fallen into ill use as a parking garage. They separated the building, with the one-third that faced Gold becoming the taproom and the back two-thirds becoming the brewery area. Boese Brothers opened in August 2015 to an enthusiastic downtown crowd, a mix of businesspeople and younger, often blue-collar patrons. "To the maximum extent possible, I tried to source stuff [from]

The massive new Rio Bravo Brewing is connected to the downtown brewpub in name only. *Author's collection.*

Albuquerque," George Boese said. "Our shirts were made down the street. Our menus were printed next door. I try to do as much as I can. Especially for us, we're trying to help downtown change its reputation and do something different. We're trying to partner up with as many [other businesses] as we can to help everyone out and maybe get people to help us."

Boese Brothers ran out a series of regular beers from its fifteen-barrel brewhouse, including Dr. Strangehop XPA, La Onza White Ale, Patriot Porter and Duke City Lager, the latter of which it has sold in kegs to bars and restaurants around town. Seasonals have come and gone, although Oktoberfest and Ichabod's Revenge, a pumpkin ale, have become annual fixtures.

The biggest brewery to debut in 2015 carried a familiar name. Rio Bravo Brewing, take two, opened inside the old Firestone tire showroom and warehouse at 1912 Second Street Northwest in September. The new brewery had no relation to its downtown predecessor. Owned by the husband-and-wife team of Randy and Denise Baker, who also owned the successful DRB Electric, the new Rio Bravo was a massive undertaking. With 14,500 square feet of available space, it loomed as the largest debut in recent Albuquerque history.

The Bakers hired Ty Levis, the son of Santa Fe Brewing founder Mike Levis, as head brewer. Ty Levis had parted ways with his father's old company after rising up to the position of director of brewery operations. At Rio Bravo,

A second Rio Bravo Brewing, with no connection to the first, opened on Second Street in the Wells Park neighborhood in 2015. *Author's collection.*

Levis, as head brewer, was given a state-of-the-art fifteen-barrel brewhouse, plus copious amounts of space in which to add future equipment.

Rio Bravo's ambitions were evident from the start, not merely in the size of the space or the quality of the equipment but in how fast the brewery was aiming to move into canning and distributing its beers. Rio Bravo did not can just one beer but rather multiple styles, including its Dirty Rotten Bastard IPA, Snakebite IPA, Duke City Pilsner and more. "In the grand scheme of things, though, what we've been able to do in such a short time—eighteen months [ago] they closed on the building, for five months there was no installation of anything, it was all gutting, renovation, plumbing work," Levis said in April 2016. "We didn't even really start framing until after April [2015]. When stuff started hitting, it hit fast."

The brewery did create some controversy when it applied for a Bernalillo County Industrial Revenue Bond, valued at up to $5 million, to aid in its continued expansion. "[Randy] keeps hearing rumors about his IRB, and how he got it, and what we did and how we're just swimming in a big pool of money over here because we got an IRB for $5 million," Levis said. "It's quite the opposite. It's a deferment of your property tax for a period of twenty years."

Rio Bravo's arrival in 2015 certainly shook up the local brewing scene with its sheer size, scope and ambition. The following year, however, would see the return of more modest start-up breweries.

The Surge of 2016

Brewery openings at the start of 2016 came so fast and furious it was almost impossible for the public to keep up.

Sidetrack Brewing opened right at the start of the year, January 2 to be precise. A small brewery in size and scope, it opened in what had previously been the offices of an architectural firm, whose owners, the Herrs and Slagles, wanted to start a small pub-style brewery. The location on Second Street, between Lead and Coal, was slightly off the main downtown beaten path.

Dan Herr handled the brewing, creating beers like RailHead Red, Dark Engine Stout and Pub Ale, on a seven-barrel brewhouse in what had been an old garage in the back of the building. The small taproom was no frills, with no food—not even a television. There was an enclosed patio in the back shared with the neighboring Zendo coffee that became a popular spot for outdoor movie watching in the summer.

The Firkin Brewhouse debuted on February 4 in the Brewery District, not far from La Cumbre and Canteen at 3351 Columbia Drive Northeast. The Prohibition-themed establishment had been in the works for months. Owner/brewer Aaron Walters and his staff had appeared at the Blues & Brews Festival in May 2015 but then faced repeated delays in getting open.

Firkin debuted with a small number of beers and a limited menu of food, including sandwiches and hot dogs. It quickly found a problem attracting people to the building, which was on a street that did not connect to either of the two main east–west thoroughfares in the area, Candelaria and Comanche. The four-person ownership soon had a falling out, with Walters and his father, Bill Walters, being pushed out by Mike Trissell and Dave Singer by June.

After a brief shutdown in early July, the brewery reopened with Trissell handling the brewing duties. As of October, it was unknown if the legal dispute between the two sets of owners had been resolved. "We were [shut] down only two or three days," Singer said. "We got things in order. We were back up and running. We just had a meeting [recently] with doing some advertising, some radio, probably some TV. It's just a matter of pushing forward and trying to get people in the door. It's all we can do."

The early road has been a lot less bumpy at Starr Brothers Brewing, which opened in late January on San Antonio, just east of Interstate 25 before the traffic light at San Pedro. Utilizing a full kitchen, the brewpub initially opened with guest taps only before its own beers from brewer Rob Whitlock would finally appear in April.

Quarter Celtic Brewpub was the creation of several partners with ties to the Canteen Brewhouse/Il Vicino. *Author's collection.*

Owners John and Heather Starr found their brewpub packed almost daily. Avid soccer fans, they soon began opening early on weekends to show English Premier League games, while also hosting parties for the local team, the Albuquerque Sol. Starr Brothers' green chile hamburger finished second in a contest at the 2016 New Mexico State Fair.

Whitlock, a home brewer and retired plumber, had worked with Justin Hamilton at Boxing Bear to help prepare himself for the job. His initial beers included Starrstruck IPA, Red Zepplin, Thunderr Ale (IPA), Lampshade Porter, Electric Sun (Hefeweizen) and L.A. Woman (Blonde Ale). With sizable residential neighborhoods all around it, Starr Brothers had a strong customer base and seemingly a bright future.

The brewpub trend continued with Quarter Celtic, which opened in late February. Located in a mostly empty shopping center at the intersection of Lomas and San Mateo, Quarter Celtic was the creation of a group of owners that included longtime Canteen/Il Vicino head brewer Brady McKeown and his brother, Ror McKeown, who had served as Canteen's general manager.

Quarter Celtic had a full kitchen, offering up a mix of American and more traditional Irish/Celtic fare, ranging from corned beef and cabbage to fish and chips. Brady McKeown and his assistant brewer, David Facey, who had also worked at Canteen and Chama River, created an initial lineup that included Crimson Lass (Irish Red), Mor-buck IPA, Knotted Blonde, Quarter Porter and Rye't Side of Dublin, a rye pale ale.

A large dining area, spacious patio outside and the added bonus of one of the city's most experienced and awarded brewers combined to help Quarter Celtic take off. The brewpub was breathing life into an area of town where local businesses had come and gone. "We did it so conservatively, the business plan is set for four years out," Brady McKeown said. "We don't have to take out more loans and stuff. Things are coming faster, but…we're not going to be Marble. At least on paper, we're fine. It's been good. The neighborhood has accepted us. We have sold a few kegs here and there. We have to figure out how many more kegs to sell to see if it's worth it. We'd like to get a few tap handles here and there."

Bow & Arrow Brewing opened on Sixth Street near Interstate 25 right around Valentine's Day. The spacious, artisan space was one of the only female-owned breweries in the state. Shyla Sheppard was appointed as CEO out of the ownership group, hiring Luke Steadman as head brewer. Steadman was brought in from back east, as he had learned at breweries in Pennsylvania and Michigan.

Bow & Arrow went with the no-frills approach, with no kitchen beyond a few snacks, such as flavored popcorn, and no televisions. There were lengthy community tables inside and a small patio out front, near where food trucks could park. Steadman's beers were traditional, but they often had a twist, using local New Mexico ingredients. Tumbling Waters (American wheat), Sun Dagger (saison), Flint & Grit (English mild ale), Crossed Arrows (Scotch) and Hoka Hey (IPA) made up the core lineup.

After the surge of five breweries in six weeks, things quieted down until Dialogue Brewing opened north of downtown in September. Dialogue took over an empty warehouse at the corner of First Street and Kinley Avenue, five blocks north of Marble. "This is a warehouse that was built in the '20s," said Eliot Salgado, one of the owners and previously a bar manager at Nob Hill Bar & Grill. "We were able to take this beautiful place and repurpose it for a whole new century and a whole new thing. The beer for us…it's super important that the beer is on par or hopefully better than what we have [in Albuquerque]. But we wanted to create a space that matches that."

Brewer Ian Graham, hired from Greenport Harbor Brewing on Long Island, New York, created a lineup of beers that was geared more to traditional Belgian and German styles. From a Berliner Weisse to a Belgian citrus IPA, the first few beers were enjoyed by patrons in the unique and towering sculpture garden in the patio outside. Dialogue was just finding its footing as 2016 was coming to a close.

TAPROOMS AND EXPANSIONS

Even as one new brewery after another opened, the older and more established breweries continued to either physically expand or add satellite taprooms. In 2015, laws were passed in Santa Fe enabling breweries to operate up to three taprooms beyond the primary brewery building. Many breweries already had at least one taproom before that.

A few breweries opened locations outside their home cities. Bosque put a taproom in Las Cruces, where many of the owners attended college at New Mexico State University. Marble would open and later close a taproom in Santa Fe. Meanwhile, Santa Fe Brewing would open a taproom in Albuquerque at the Green Jeans Farmery, a unique business park made up of repurposed railcar storage containers. Santa Fe's Duel Brewing opened a large taproom in downtown Albuquerque on Central between Sixth and Seventh Streets. The Abbey Brewing Company, owned by the monks at the Monastery of Christ in the Desert in Abiquiu, opened a taproom called Monk's Corner in downtown Albuquerque at the corner of Silver and Third Street in September 2016. Bernalillo's Kaktus Brewing opened a taproom in Nob Hill, offering up the same selection of beer and a slightly different food menu.

In addition to Bosque's Nob Hill taproom, other breweries opened taprooms around the Albuquerque metro area. Marble's Westside Taproom, located on Unser north of McMahon, opened back in 2012 and was expanded in two separate buildouts due to its popularity. Marble opened a Northeast Heights taproom inside a renovated old post office building on Montgomery east of Eubank in 2016.

Canteen opened its first taproom at Cloudview and Tramway, just north of Interstate 40, giving the Sandia Mountain foothills area its first craft beer taproom in 2016. Nexus also chose an area of the city without any nearby breweries or taprooms, placing Nexus Silver on Coors just north of Interstate 40 on the west side. Red Door placed a taproom downtown at Gold and Fourth Street inside the Simms Building, the first modern high-rise in Albuquerque, which was undergoing a renovation in the retail spaces on its ground floor.

In order to accommodate the growing thirst of their customers, La Cumbre and Marble both underwent sizable expansions of their brewing areas. They added new, larger brewhouses and many more fermenters. Marble's new 30-barrel brewhouse would feed into towering 120-barrel fermenters in the huge new fermentation hall built onto the north end

The current thirty-barrel brewhouse at La Cumbre was added in 2015. *Author's collection.*

of the existing building, taking the space of the old parking lot. The two breweries also renovated their primary taprooms, while La Cumbre added a small patio and Marble added a rooftop deck atop its taproom.

The construction and expansion all around Albuquerque's breweries was continuing as 2016 was coming to an end. The post-Marble brewery boom continued to surge with no end in sight.

Booming in the Burbs

Census estimates place the Albuquerque Metropolitan Area in excess of 900,000 people as of 2016. More than 550,000 live within the city limits, while the rest are scattered throughout a series of communities defined as suburbs, although most are loath to refer to themselves as such. Still, with thirsty populations of their own, the suburbs have welcomed breweries from time to time. Some of the breweries came and went quickly. Others have succeeded against the odds.

The unincorporated communities of the East Mountains, defined as the area east of the Sandia Mountains that forms Albuquerque's eastern border, are sparsely populated and have only twice had small brewing operations. To the south, the towns of Valencia County have featured just one brewery, one that proved successful enough to eventually move its operations to Albuquerque. To the north, the small town of Bernalillo is on its second brewery, one much smaller than its early 2000s predecessor that came and went. Finally, to the northwest of Albuquerque is Rio Rancho, which is technically the third-largest municipality in New Mexico with more than ninety thousand residents, smaller than its neighbor and Las Cruces but bigger than even the capital of Santa Fe. It has featured four breweries in its history, three of which were still in operation at the end of 2016.

Manzano Mountain Brewery

Little is known of Manzano Mountain, which many observers said never really opened in 1991 in the East Mountains community of Tijeras. Former Cabezon owner/brewer Mike Carver, who lives in the area, said it never really got going. Scattered records showed that Steve Maase, a local musician and home brewer, attempted to open a brewery in Tijeras but had given up by 1992. Maase, who died in 2016, was a relative unknown to the current craft brewing community in the Albuquerque area.

An article from the Michael Jackson Beer Hunter website described the author meeting Maase (spelled "Maas" in the story) and wondering whether or not Manzano Mountain was operating legally. It did mention that Maase had used his Class Axe Classic, a hoppy red ale, as a means of promoting his band, Class Axe. As a side note, Jackson's local beer guides in the story included Tom Hart, later of Rio Grande, and Guy Ruth, later of San Ysidro and Dry Gulch. Both were members of the Dukes of Ale home brew club at the time.

Volcano Brewery

The first brewery in Rio Rancho sprang up in November 1996. Allen Holder and his wife, Melissa, opened Volcano Brewery at 206 Frontage Road, just off the town's main north–south artery, Highway 528/Rio Rancho Boulevard.

Volcano followed the path of Rio Grande and Cabezon, mainly bottling and selling its beer off site. Volcano Pale Ale was the flagship, with two other unnamed beers also being sold. The beers were also on tap at O'Hare's, a pub on Southern Boulevard, as well as the Chili's restaurant near Albuquerque's Cottonwood Mall on the west side and at Village Pizza in Corrales.

With a limited budget and amount of space, Holder, an engineer who had worked at Rio Rancho's massive Intel factory, was unable to keep up. The brewery was out of business by the time Nico Ortiz had Turtle Mountain up and running. "[Holder] closed up shop just after we opened up," Ortiz recalled. "He was trying to sell me some of his grain. I went down there and met him. He was an Intel guy. I do remember when I came up to Rio Rancho in '98 to do a site visit, their beer was on tap at O'Hare's. Terry and I went down to the industrial park, [and] we toured his brewery and tried his beer. That was in 1998. By 1999, he was closed. I used to look at the equipment in the back of his house."

TURTLE MOUNTAIN BREWING

Turtle Mountain Brewing owner Nico Ortiz (*center*) poses in his original brewpub location in Rio Rancho. *Courtesy of Turtle Mountain Brewing.*

Nico Ortiz was a New Mexico native, armed with a master's degree in business from Northwestern University, who could not shake his love of quality beer. It stemmed from a visit to Germany when he was young. By the 1990s, Ortiz was beginning to dream of opening his own brewery, something he shared with those who were already in the business, such as Brad Kraus at the original Rio Bravo. "That's where I first met Nico Ortiz," Kraus said. "He just loved the beer. He'd come in and drink the beer all the time. He can confirm it, but he used to tell me that's what motivated him to start Turtle Mountain."

Ortiz also frequented the original Il Vicino in Nob Hill. "I remember Nico used to sit at the bar and talk to us about it all the time," Brady McKeown said.

Ortiz viewed Albuquerque as already being saturated with breweries by 1998, so a friend suggested that he take a look at the fast-growing suburb to the northwest. "I came out in '98 for the site visit with my buddy Derek, who was a past president of the Dukes back in the heyday," Ortiz said. "He was like, 'Why don't you look at Rio Rancho for Turtle Mountain?' Every other desirable part of town already had breweries back then. I came up here, and the demographic was great; it was a young city, but then I could see why nobody had come up here. It's a tough market. There's a lot of people, but trying to extract money from their wallets was tough. These were some frugal-ass people. They live out here because it's cheap."

Still, Ortiz pushed ahead. He found himself in luck when he met Mark Matheson, who had been pushed out at Assets Grille and Brewery in 1998. Matheson had returned to winemaking, but Ortiz gave him the opportunity to start brewing again. They took over a former laundromat on Southern Boulevard, converting it into a brewpub with a full kitchen, and opened in 1999. It took a while for anyone in town to notice.

Turtle Mountain became Rio Rancho's second brewery when it opened its doors in 1999. *Courtesy of Turtle Mountain Brewing.*

"Rio Rancho basically has Southern Boulevard, Northern Boulevard, Unser and 528. Northern and Southern go east-to-west, Unser and 528 go north-to-south. There were basically four roads in this town, and we were on one of them," Ortiz explained. "Intel was at full strength; they had like 6,500 employees. We were getting thousands and thousands and thousands of people driving by Turtle Mountain every day. It said Turtle Mountain Brewing Company, but they didn't know that we served food because it said brewing company. They're like, brewing company, I don't know how many times we had people walk in and say, 'Hey, I've been driving by for like nine months, and this is the first time I've stopped in.' I'm like, 'You drive by every day for nine months and you don't stop in?'"

Local advertising did not really exist for Rio Rancho, where only a scattered few picked up a zoned edition of the *Albuquerque Journal*. The local *Rio Rancho Observer* did not publish daily, and as Ortiz put it best, "People would just drive over it in their driveway." In the end, it was word of mouth, especially at the town's largest employer, that ultimately convinced people to try the fledgling brewpub. "Intel was definitely key," Ortiz said. "We got into the hive, so to speak. Intel literally kept us open because we got enough people that would come in for the happy hours and stuff. Word filtered out because a lot of those guys, they came from Oregon [and] a lot of states that had a more progressive beer culture. We would get a ton of Intel people who had a ton of money, and they would drink a lot of beer."

It took four years from opening in 1999 for Turtle Mountain to grow a stable customer base. Ortiz told stories of people walking into the brewpub, a year after it opened, with laundry baskets, unaware that the prior business had been gone for twelve months. "It took time, at least as far as Rio Rancho went," Ortiz said. "It was somewhat gradual, but finally we hit the critical mass where enough people knew about us. The place was only seventy-eight seats. On Friday nights, there would be an hour-and-a-half wait. We finally

became the local watering hole. No other restaurants came in. So, finally we're dialing in the beers, we dialed in the food and we became the local hangout at that point."

Faced with overwhelming demand and limited space, Ortiz purchased the land where the brewpub now exists, just west of the original location at 905 Thirty-Sixth Street, a small

Turtle Mountain moved into its current, larger location on Southern Boulevard in 2006. *Courtesy of Turtle Mountain Brewing.*

road with no outlet right off Southern near the town's main post office. "For like the first two or three years, I'm not sleeping at night," Ortiz said. "But then it's like I'm not sleeping at night again because it's too busy, we can't expand, we don't have air conditioning, the landlord is an asshole. Now we have the problem on the positive side. We can no longer produce good beer because people are drinking it faster than we can make it."

The current location opened on September 10, 2006. It has remained a staple of Rio Rancho ever since, frequently finishing first or second in polls asking about the community's best restaurant.

Matheson would eventually part ways with Turtle Mountain, succeeded by former Chama River assistant brewer Tim Woodward in early 2014. "I was with Turtle and Nico for fourteen years," Matheson said. "I had a good run there. It was a time for a change for both of us. It was a good deal."

Woodward solidified the constantly rotating lineup of beers, putting a core group in place that included Hopshell IPA, McDay's Cream Ale, Parasol White IPA, Oku Amber, Stauffenberg Stout and Heidelberg Helles, the latter named after Ortiz's favorite German town. Eventually, Woodward moved to Bosque Brewing to run its future production facility in Bernalillo. Ortiz did not have to look far for his replacement, plucking Mick Hahn from Marble Brewery, where he had served as an assistant brewer.

Turtle Mountain was still going strong at the end of 2016, the biggest success story of any brewery in Albuquerque's suburbs. Its only rival to that claim started in a suburb to the south but would finish in the heart of the city.

TRACTOR BREWING

Just south of Albuquerque are the towns that make up Valencia County. Primarily agricultural in nature, Los Lunas and Belen sit on both sides of the Rio Grande. The former was home to Herb Pluemer, a Wisconsin native who was looking to transition into a new business as he retired from a long career in engineering. Pluemer decided that he would open a brewery in the back of a restaurant he owned, RIBS Hickory Pit Barbecue.

Mike Campbell had found himself out of a brewing job when Alvarado Brewing had shut down in 1998. He ended up working with Brad Kraus at Wolf Canyon Brewing in Santa Fe, but Campbell grew weary of the 120-mile round-trip commute. Campbell met Pluemer and was hired to get Tractor Brewing off the ground. "[Pluemer] had bought the tanks and they were on a concrete pad that the walls weren't completely put up yet," Campbell said. "Those metal buildings, metal warehouses, you've got the big girders and sheet metal screws, a million of those to put up the sides. We started with that. It wasn't long that we had poured another concrete pad and made another building next to it, knocked out the walls and doubled the size of the brewery, got thirty-barrel fermenters."

Campbell was basically a one-man show at Tractor, handling every conceivable job in the brewery. After the decision was made to start bottling the beer, he even handled sales and distribution. "It was a smashing success," Campbell said. "I decided to keep it to about ten places and preferably up and down Central [Avenue] because I was the brewer, I was the kegger, I was the line cleaner, I was the deliverer—I was the only one."

Campbell found some of the bars and restaurants in Albuquerque to be quite receptive to his beers. "O'Niell's did me well with Tractor," he said. "They didn't want to wait. I knew a lot of the restaurant and bar owners by working part-time as a delivery driver for a company that was called the Wine Patrol. The guy at O'Niell's was pretty much the first customer. Their O-Red was Tractor Red for years and years. It would tell you on the menu."

Campbell also handled promotion for the brewery, coining many of the catchphrases still in use today. "The first bottle we labeled was the Farmer's Tan Red," he said. "It had getplowed.com on it. I came up with that. I was actually pretty proud of the names and the culture we made. When I joined them, they had the tanks and the floor and the name. Tractor, what am I going to do with that? Then I came up with Sodbuster, Haymaker, Double Plow, Get Plowed."

To prove that Albuquerque is not just a beer town, Tractor recently began canning and distributing its popular Delicious Red Hard Apple Cider. *Courtesy of Tractor Brewing.*

Like many other breweries in Albuquerque, Tractor began to struggle around 2005. Pluemer brought in Skye Devore to run the business. She and Campbell were soon at odds, prompting him to leave in 2007. Pluemer nearly shut down the brewery in 2008, but new brewer James Walton kept things going until he left in 2010, at which point David Hargis was hired.

Devore and Hargis eventually purchased Tractor from Pluemer, becoming co-owners in 2013. By that time, the brewery's Nob Hill taproom was driving its sales, and the move to restart packaging was underway. The decision was made to shift the entire brewing operation to a new facility in Albuquerque's Wells Park neighborhood, north of downtown, in early 2014.

WESTWIND/MILAGRO BREWERY

The history of Bernalillo's first brewery is a convoluted one. The old Westwind Winery building, located off Highway 550 near the Santa Ana Star Casino, became the site of a small brewery run by Mike Buckner and his wife called Westwind Brewery. Buckner had started the original Albuquerque Brewing in 1988 before bowing out some time in the early

1990s. "I remember Mike's Resurrection Ale in Bernalillo," Ortiz said, noting that it may have been there as far back as 1995.

Health issues reportedly forced out Buckner, while a new group led by local businessman Larry Logan took over the site, renaming it the Milagro Brewery and Grill in 2001. Robert E. Lee and Peter Fieweger were hired to handle the brewing, while a full kitchen was installed. "That system, oh my god, I remember going there, and [Lee] had to cut a chunk out of the jacket of the kettle because prior to them being on city water they were on well and it was super, super hard water," Ortiz recalled. "Calcium had clogged the jacket. He was lucky it didn't explode. He had to cut a hole in the jacket and hand-chisel the scale out of the kettle. He was a super hands-on guy. He was able to keep that system together. Running a frickin' brewery of that size on well water, I'm like, Jesus."

Milagro stumbled and sputtered, eventually closing up shop in February 2005. "It's just one of those things that ground to a halt," Logan told the *Albuquerque Journal*. "We just couldn't make it." Fieweger would move on to Three Rivers Brewery in Farmington, where he became the head brewer in 2011.

As for Bernalillo, the small town would be without its own brewery until 2013, when a much smaller operation popped up in a truly unusual setting.

KAKTUS BREWING

Mark Matheson had met John Koller back in the 1990s when Matheson still brewed at Assets. The two remained friends while Matheson transitioned to Turtle Mountain. Later, Matheson got to know Dana Koller, John's son, through the New Mexico Wine Growers Association. Dana Koller was a sales and marketing expert who developed an itch to start a small brewery in Bernalillo.

"It was at the end of the weekend, and we're drinking some beer at his dad's house and Dana points at this garage and says we should do a brewery [there]," Matheson recalled, telling Koller that was not a good idea. Matheson's wife thought otherwise. "I've been married for twenty-six years, and the one thing I've learned is that you listen to your wife. She knew and I knew that I was basically at the end of the road at Turtle Mountain and I needed to leave. She said I needed to do it and see if I could figure it out."

Koller and Matheson purchased a two-barrel brewing system from a company in Germany. They transformed the unused garage building into a

small brewing space with an adjacent taproom. Matheson did not plan to be involved on a daily basis in the brewing, so he hired Michael Waddy as brewer. "Frankly, I'm fifty-three, and I've been making wine and doing beer since I was twenty-two," Matheson said. "The physical toll, it's definitely there. I wanted something easy on the body. Mike Waddy, he's like a son, he and my son are like brothers. It's a nice fit."

Bernalillo's Kaktus Brewing has become a haven for local artists, one of whom was clearly a fan of the television series *Breaking Bad*. *Author's collection.*

Kaktus opened its doors on October 7, 2013, at 471 South Hill Road, just south of the main drag of Highway 550. Its neighbors include a number of farms and a KOA Kampground. "It just made sense," Koller said in 2013. "There was nobody on the north side of [the metro area] servicing Algodones, Placitas, Bernalillo, Enchanted Hills of Rio Rancho, all these places. It made sense to be the one to come in and service them as a community brewery."

Kaktus offered up a rotating selection of beers, with the Helles Lager becoming the most popular for the locals. There were also an ESB and a London porter, plus of course an IPA. A small food prep area produced pizzas and sausages with some unique toppings and ingredients. It all came in a comfortable, relaxed setting. The outdoor patio was a popular spot in the warmer months, and Koller had it enclosed in a heated tent for the colder months.

"We definitely wanted to give that feeling [of community] to people. In New Mexico, all of the new breweries have a similar theme—a warehouse, kind of more of an urban feel to it, more of a metro look. We wanted to be more comfortable than that. We wanted a place where people can come in, bring their dogs, bring their family, bring their kids, [make it] a kid-friendly environment," Koller said. "So, we didn't want to be just like a bar. We wanted to bring back the old feeling of a pub. We're doing our best to 'X' out the televisions. We want people to talk, we want people to really get to know each other, we want to build a community. So it's important for us to

give that feeling. When people leave, they say exactly what we were going for: 'I just had a beer at a friend's house.' That's exactly what we wanted."

Kaktus would go on to enjoy enough success to open a taproom in Albuquerque's Nob Hill district in December 2015.

CAZUELA'S MEXICAN GRILL AND BREWERY

The number of existing restaurants that transformed into brewpubs, as Assets and Il Vicino had done in the 1990s, was still a small one in the new century. Las Cazuela's Mexican Grill, located at 4051 Sara Road in Rio Rancho, decided to join the fray in 2013. A banquet area behind the bar was rebuilt as the home of a seven-barrel brewhouse. All the new operation needed was a brewer.

Mike Campbell had journeyed all the way to Memphis, Tennessee, to continue his brewing career after parting ways with Tractor in 2007. He worked at Ghost River Brewing from 2008 to 2011. Campbell returned to Albuquerque in 2012, even though, at that point, there were no brewer positions available. "I could definitely see the difference," Campbell said of the local scene. "When I left, Marble had just purchased the land; they had done nothing of any development. I was very surprised to see what Marble had done. Thankfully, one of their fests was just within a few weeks of me getting back in town, so I was able to see a lot of the people [in brewing]."

That little bit of networking brought Campbell to the attention of the Cazuela's owners, who hired him to get the brewery up and running in the summer of 2013. Soon, customers were sipping on pints of Acapulco Gold, Chupacabra IPA and Panama Red. Two of the brewery's best sellers besides the Acapulco were Piedra del Fuego, a stoned cream ale, where hot granite stones were added to the wort to help carmelize the sugars, and Beer for My Horses, an oatmeal stout that brought home a bronze medal from the 2014 World Beer Cup. "The beer has definitely been a great hit," said Cazuela's owner Francisco Saenz at the end of 2014. "It was great to put a microbrewery into my restaurant. We have always had a large customer base because of the food we make, but the beer has helped us out quite a bit."

Saenz said that he planned to open a taproom in Albuquerque in 2015, but that plan never came to fruition. Campbell would eventually leave Cazuela's in 2015 with plans to open his own brewery, OffKilter,

on Albuquerque's east side. It was later rebranded as Drafty Kilt, but by October 2016 it was still not open.

Cazuela's hired Brandon Venaglia, who had worked at the Back Alley Draft House in downtown Albuquerque, as its new head brewer.

The Blue Grasshopper Brew Pub

A third Rio Rancho brewery, much smaller in scale than Turtle Mountain and Cazuela's, opened in October 2014. The Blue Grasshopper Brew Pub was the creation of former college instructor Greg Nielsen and his friend Peter Apers, a general contractor who was born and raised in the Netherlands near the German and Belgian borders.

They set up a small pub at 4500 Arrowhead Ridge Drive, complete with a wood-fired pizza oven and small kitchen, plus an extensive tap list of beers from around New Mexico. Apers would brew up one or more beers at a time, a constant rotation of styles inspired by his home country and its close neighbors, Belgium and Germany. "I'm from Holland, and I kind of grew up with beer because I was situated between the southern border of Holland with Belgium and western Germany; that's 'Beer Mecca,'" Apers said in 2014. "And so I've always been interested in beer."

Apers came up with the pub's name based on his childhood guitar teacher's nickname for him, which stemmed from the television series *Kung Fu*. Apers was dubbed the "Blues Grasshopper" after David Carradine's character.

Thanks to Apers's musical background, Blue Grasshopper also embraced live entertainment, booking bands to perform most nights. There were also board games and other activities for patrons to enjoy. "We've got twenty-seven thousand people living behind us," Apers said. "Why do you think Turtle Mountain is packed every day?…People are hungry for another place, and they don't want to go to Albuquerque."

By late 2016, Nielsen and Apers had announced that they would open a taproom at 6361 Riverside Plaza Lane in Albuquerque, just north of the Coors and Montano intersection. "I think it's going to be a really good location, and the visibility in that location will be much higher," Nielsen told *Albuquerque Business First*. The taproom was originally scheduled to open in October, although by the end of the month it was still not operational.

ALE REPUBLIC

Longtime friends Patrick Johnson and Zach Gould were beer geeks of a high order, joining "underground" bottle shares with their friends to sample rare beers from around the country and the world, plus members' home brews. By 2014, they had decided that the concept could go quite a bit further. "We came up with this concept of where we're launching off the Beer Underground," Gould said. "The deal with that was we have New Mexico beers and home brews [for tasting]....But it was becoming too popular; we had too many people. We decided we needed to expand or something. We wondered how we could [adapt] that."

Their initial plan called for opening a brewery near downtown Albuquerque, one that would offer up guest taps from other New Mexico breweries. They would then brew their own beer, often using recipes created by their customers. Ale Republic, as they dubbed this endeavor, would be a democratic brewery, with many people getting the opportunity to show off and/or hone their skills as brewers.

Ultimately, however, plans for an Albuquerque-based location were abandoned. The Ale Republic instead found a small building in Cedar Crest, in the East Mountains, in which to start its small brewing operation.

The Ale Republic finally opened in late August 2016, offering up a blonde ale alongside a number of guest taps from other New Mexico breweries. The

Cedar Crest, located in the Sandia Mountains east of Albuquerque, saw the opening of its first brewery in 2016, the Ale Republic. *Author's collection.*

concept of a democratic brewery has not been abandoned, although for now Johnson will handle most of the brewing from his own recipes.

At the very least, the Ale Republic had done what Manzano Mountain had failed to do back in 1991, which was open a small brewery in the East Mountains. Through fits and starts, Albuquerque's suburbs had shown the ability to sustain their own breweries. Much like the city itself, these communities were also embracing the craft beer boom.

Hauling Medals and Firing Up Competition

Throughout the resurgence of the Albuquerque brewing scene, the quest for a little added recognition, beyond just the usual beer sales and thumbs up from customers, has been apparent for each brewery as they have come along.

Some of that recognition has come at the national or even international levels, mainly from two of the biggest beer competitions at the Great American Beer Festival and World Beer Cup. It has also come through one particular local competition, the New Mexico IPA Challenge. Whatever the event, local brewers have been eager to pit their finest creations against their friends' and colleagues' best offerings. Bragging rights, after all, are often just as coveted as the hardware that comes with them.

GREAT AMERICAN BEER FESTIVAL

Known by its acronym, GABF is the largest beer festival in North America. It was organized by Charlie Papazian and the Brewers Association in Denver in 1982. An estimated eight hundred people attended the first GABF. By the thirty-fifth edition in 2016, there were 780 breweries set up inside offering up samples of their beer, while a total of 1,752 breweries were entered into the competition.

The first beer made in New Mexico to capture a medal at GABF was Santa Fe's Nut Brown Ale, which earned a bronze in 1991. Santa Fe claimed

another bronze with Sangre De Frambuesa in 1992, followed by Taos's Eske's Brew Pub snagging a bronze for its Green Chile Beer in 1993.

An Albuquerque brewery finally earned a medal in 1995 when Il Vicino's Wet Mountain IPA took bronze in the American-Style IPA category. Il Vicino would add a silver in 1996 for Tenderfoot Brown Ale and a bronze in 1998 for Alien Ale, an English-style bitter. Rio Grande won a silver for Pancho Verde Chile Cerveza in 1996 and a bronze in 1998.

Il Vicino's Slow Down Brown captured another bronze in 2002, the same year that Blue Corn Albuquerque picked up its first medal, a silver for Get Off My Bock. The future Chama River earned Albuquerque's first gold medal in 2003 with its Atomic Blonde. Although the brewery was still not officially Chama, it entered beers under that name in the 2004 competition, taking another gold for Rye On. Il Vicino added two more medals that year, a silver for Roggenbock and a bronze for Slow Down Brown.

Beginning in 2008, Albuquerque breweries have claimed one or more medals in nine straight competitions. From 2008 to 2010, Chama River added four more medals under Jeff Erway and Justin Hamilton, including gold medals for Herbal Joe's Columbarillo IPA in the Pro-Am Competition in 2009 and for 3 Dog Night, a Baltic porter, in 2010. Il Vicino picked up silver medals for Sweet Sandarine Porter in 2008 and St. Bob's Imperial Stout in 2009.

Relative newcomers Marble and La Cumbre broke through in 2011. Marble earned a bronze for its pilsner, while La Cumbre took two golds for Elevated IPA and BEER, plus a silver for Malpais Stout.

Marble would snag a silver for Imperial Red and a bronze for Double White in 2012, while Il Vicino earned bronze for Milk Chocolate Cherry Stout. Moriarty's Sierra Blanca claimed gold for its Nut Brown Ale.

New Mexico breweries would claim a record eight medals between them in 2013 and 2014, with ten of those medals earned by Albuquerque breweries. Marble picked up a silver for its pilsner and a bronze for Thunder from Dortmunder in 2013, while La Cumbre earned bronze for Project Dank: Operation Pharoah's Return, an IPA, and Il Vicino finally captured an elusive gold medal with Panama Joe Coffee Stout. "It's always fun, at least for the brewers, to do the competitions and see how you're doing," Brady McKeown said in 2013. "We did well, so we're happy for that. We hope a little bit of that has translated into new faces in the seats."

The following year would be even bigger. Marble was awarded gold medals for Double White and Imperial Red, which in turn led to the Small Brewery of the Year Award. It was a first for any New Mexico brewery.

"Imperial Red was our last category," said Marble brewmaster/president Ted Rice. "It didn't really cross my mind that Small Brewery of the Year could be on the table. So, we win Imperial Red, and I move to a different section in the theater to go hang out with my friends from Telluride Brewing Company. My buddy says to me, 'Nobody else has won two golds, you could win Small Brewery of the Year.' I'm like, 'No way!' I stayed there for the rest of the announcement. And, lo and behold, we're up there, grins ear to ear, accepting that award as well. After that, just walk on over to the festival floor and just have some fun and try to keep it level, keep it real."

In addition, Canteen (née Il Vicino) picked up gold for Dougie Style Amber and silver for St. Bob's Imperial Stout '07. Chama River returned to the proverbial medals stand with gold for Class VI Golden Lager. Bosque, in its GABF debut, snagged a bronze for Acequia IPA in the Fresh or Wet Hop category. "All I do remember is after we won, I didn't hear anything about the next seven categories," said then Chama River brewer Zach Guilmette. "As they kept announcing winners, I was in shock, texting friends and getting texts from people. I was just enjoying that moment."

Rice was enjoying every minute of seeing the state's breweries succeed in 2014. "It's pretty amazing," he said. "Where have we come? We've come to be a force to be reckoned with. A lot of people, yeah, maybe dismiss us because we're down here in this sparsely populated state. But as I always tell people, the people that live in New Mexico love big, bold flavors, so the brewers are following hand in hand with the citizens' palates, just bringing big, bold flavors."

Things slowed down just a bit in 2015, with only four medals. Bosque moved up to gold for Acequia IPA, while Marble added a bronze for Imperial Red. Nexus earned its first medal with a silver for Honey Chamomile Wheat. Boxing Bear also took home its first medal, a silver for Chocolate Milk Stout. "It's huge. It's absolutely huge," Bosque head brewer John Bullard said of his first gold medal. "I don't know what else to say. It's the biggest. It took a few days for that to sink in. A lot of respect comes from that, and that helps a lot. Especially being a younger brewer—in Albuquerque I'm one of the younger brewers, of course. That helps a whole lot with gaining more respect from a lot of my, I guess you could call them colleagues. That's a good thing."

Boxing Bear would be the big winner in 2016. The brewery, barely two years old, earned gold for Chocolate Milk Stout and the Red Glove in the Double Red category. It was seemingly not enough, however, to claim a brewery of the year award. After an internal investigation, the Brewers Association determined that San Diego's Karl Strauss Brewing had been

The team from Boxing Bear, including head brewer Justin Hamilton (*second from right*), celebrated in Denver after claiming Mid-Size Brewpub of the Year honors at the 2016 Great American Beer Festival. *Author's collection.*

misclassified as a mid-size brewpub and was instead a mid-size brewery. Karl Strauss was given that award, leaving Mid-Size Brewpub of the Year up for grabs. Boxing Bear's Hamilton was informed just prior to the final Saturday night session on October 8 that his brewpub won the award.

"I have to go to the night session, and I'm literally on my way out the door when I get a call from one of the organizers," Hamilton recalled. "'It's nothing official yet, but we wanted to let you know the whole story about Karl Strauss being in the wrong category. Basically what it leads to is that the opening is for you and you were mis-categorized as well, and now you're now the Mid-Size Brewpub of the Year.' I throw my sweatshirt down and start screaming, '[Expletive] yeah!' I had to apologize for yelling [to my wife]."

That capped another medal-laden afternoon, as Marble took another bronze for its pilsner, La Cumbre earned a bronze for Siberian Silk (Baltic porter) and Bosque went away with two silvers for Acequia IPA and Bosque Lager.

As of the end of 2016, Canteen/Il Vicino has won the most medals with twelve (two gold, six silver and four bronze), with Marble second with nine (two gold, two silver and five bronze) and Chama River/Blue Corn Albuquerque third with seven (four gold, one silver and two bronze). Not too shabby for a state with just over 2 million people and fewer than seventy breweries.

WORLD BEER CUP

In contrast to GABF, the biennial World Beer Cup languished in relative obscurity in regards to the general public. By 2016, or perhaps sooner, the public members of the craft beer community had become aware of this event, which was being held at the same time as the Craft Brewers Conference in the springtime, usually April, every year at sites around the United States. Open to breweries from around the world, the WBC was nonetheless an American-dominated event.

Il Vicino, not surprisingly, was the first Albuquerque brewery to claim a medal at the WBC, taking gold for Slow Down Brown in 1996. Bavarian Lager Cellar then won its lone notable award, gold for Toothless Bock, in 1998, just months before it closed up shop.

From there, much as they did at GABF, Il Vicino and Blue Corn Albuquerque (later Chama River) were the lone medaling breweries at the WBC. Il Vicino snagged gold in 2002 for Irish Red and a bronze for Slow Down Brown. Blue Corn picked up silver for Get Off My Bock and a bronze for Red Dragon Lager, the medals that Rice once said helped put him and his still-young brewery on the map. Rice added more medals in a silver in 2004 for Rye On and a silver in 2006 for Barleywine, with the brewpub official rebranded as Chama River.

Erway then picked up two more medals for Chama in 2008 for Sleeping Dog Oatmeal Stout and 3 Dog Night (Baltic porter). The latter added another silver in 2010. Il Vicino also added a bronze for St. Bob's Imperial Stout '06 that year.

La Cumbre dominated the Albuquerque list for 2012, taking silver for Barley's Wine and Malpais Stout, plus a bronze for Elevated IPA. Nexus earned its first major medal with a silver for Imperial Cream Ale.

Marble picked up its first WBC medal with a gold in 2014 for its pilsner. Cazuela's also won that year for Beer for My Horses, which took bronze in the Oatmeal Stout category.

The biggest year to date for New Mexico was 2016 in Philadelphia, when seven breweries brought home seven medals, with six of those coming from the Albuquerque area. Boxing Bear punched its way to gold for Chocolate Milk Stout, while La Cumbre tapped gold for BEER and Nexus added a gold for Honey Chamomile Wheat. Canteen would add silver for High Plains Pils, while Marble picked up another bronze for its pilsner and Bosque took home a bronze for its IPA.

"I was walking down the street in Philadelphia," Erway said. "I'd made the ceremony several times and I didn't really need to eat that food

Bosque IPA was put into cans in late 2016, featuring its bronze medal at the World Beer Cup earlier in the year. *Courtesy of Bosque Brewing.*

anymore, so we made some reservations at a very nice steakhouse. I was listening to the ceremony and it got to my category, and I stopped in the middle of the street in the rain. And I waited. I had dozens of people looking at me as I jumped up and down and shouted profanities in the middle of the street in Philadelphia as I was walking towards this rather swanky steakhouse. And then, Daniel [Jaramillo] and Scot [Nelson] and I made a scene outside the restaurant."

It was a celebration for all the brewers, whether they were in attendance or not. "I think it means a lot, of course," Hamilton said. "It means that we knew we had good beer in New Mexico, but it's saying we still have good beer in New Mexico. It's a pretty flooded market. I don't know if *flooded* is the right word. It's a very heavy-flow market. Being that, it's good to know that the guys, and girls, who have been brewing for a long time, we [still] know what we're doing."

New Mexico IPA Challenge

Gaining the national recognition from GABF or WBC is one thing. Winning the biggest in-state competition is another. The New Mexico IPA Challenge was born out of a number of brewers bragging about who made the best

of the state's most popular style of craft beer, India pale ale, back in 2002. "As far as I can remember, we obviously take great pride in our IPAs, so we wanted to have an in-state challenge as far as bragging rights as what the best IPA in the state was," said Turtle Mountain owner Nico Ortiz. "Sort of a head-to-head type of a challenge."

The NMIPAC went through numerous changes over the years. The first edition was held at three separate venues, with the winner being decided by whomever's keg floated first. Shenanigans reportedly occurred at the first two events under this format, with the winning brewery (Blue Corn Albuquerque in 2002, Turtle Mountain in 2003) being accused of "buying" its way to victory. The decision was made for 2004 to shift to a blind taste test format.

The use of multiple locations—usually one in Albuquerque, one in Santa Fe/Northern New Mexico and one in southern New Mexico—was to try to ensure as many different types of voters as possible. This did not always work out, as the sheer population advantage of Albuquerque often ensured that round was by far the decisive number of votes.

Il Vicino's Wet Mountain IPA won back-to-back titles in 2004 and 2005, followed by Chama River's Dangerous Intentions in 2006, Turtle Mountain's TMBC IPA in 2007 and Chama's The March Hare in 2008. Brady McKeown then brewed up a new India pale lager that took first in 2009, followed by three straight wins for his Exodus IPA from 2010 to 2012.

John Bullard broke that streak with his victory for Blue Corn Santa Fe in 2013. He then added back-to-back titles with Bosque's Scale Tipper IPA in 2014 and 2015. Bullard called Scale Tipper the most expensive beer he, and

Bosque, had ever brewed. "It's always different when it comes to [voters in] Albuquerque," Bullard said. "You've seen it before, when beers really come from behind in Albuquerque. We're making an IPA that's

Boxing Bear held a limited bottling run for Bear Knuckle IPA, the winner of the 2016 New Mexico IPA Challenge. *Courtesy of Boxing Bear Brewing.*

dedicated for Albuquerque, really. That's all we're really trying to do. Las Cruces is catching on to that, but that's really what it is."

Bullard's three-year reign was ended by Boxing Bear in 2016, just one more moment in what was a huge year for the young brewery and Hamilton. "I think it's great, honestly. The reaction to it is a little bit of stunned, but we're also super happy to represent New Mexico. All of us have been locals for a long time," Hamilton said. "I grew up here, so did Dylan [Davis, assistant brewer]. For the fact that we're local brewers, that we've been involved in the brewery scene for a long time, we were able to bring it home to our new place, that's really awesome. Being that I was a part of the IPA Challenge for the last decade, and not being able to bring one home, this is hard. A lot of these guys it's their first year, second or third year. I've been doing it for a long time. After years of contention, it's nice to have that boy sitting on our bar top."

National IPA Challenge

The *Brewing News*—a regionalized, craft beer–centric newspaper—began organizing its own tournament of the top IPAs in the country in 2008. It drew in entries from across America, pitting them head to head in a fashion similar to the NCAA Basketball Tournament, with a full bracket of hyper-hopped beers.

Past winners had included entries from San Diego's Green Flash, Ohio's Fat Head's and Vermont's Lawson's Finest Liquids. In 2014, La Cumbre joined their ranks as Project Dank captured the first title for an Albuquerque brewery. "They invited me to enter the competition," Erway said. "It's grown more and more prestigious than for no other reason than the caliber of the competition. You've got a lot of breweries that are throwing their hats in the ring that are very, very well known. If you look at the beers that were entered into this competition, all three of the medaling beers from the Great American Beer Festival were in there, as well as all three from the last three years at [GABF]."

La Cumbre beat Blue Corn Santa Fe in the quarterfinals in 2014. A year later, it was Bullard's Scale Tipper that reached the final match, besting Canteen's Exodus in an all-Albuquerque final.

In 2016, Bosque accomplished a first, repeating as NMIPAC champion. No brewery—not even from craft beer hotbeds such as California,

Bosque Brewing became the first brewery in the country to capture back-to-back National IPA Challenge titles with Scale Tipper IPA in 2015 and 2016. *Author's collection.*

Colorado, Oregon and Vermont—could make that claim. "I think our whole crew is just stoked about this," said Bosque co-owner Jotham Michnovicz. "It creates a lot of good morale when you win an award like that. It reaches to every employee."

New Mexico, and Albuquerque specifically, was truly on the map as a hub of award-winning craft beer.

Of Brewers, Brewers Guilds,
Beer Geeks and Beer Fests

There are far more aspects to the craft beer culture in Albuquerque besides just the breweries themselves. A slew of festivals have emerged to help promote the beer, some sponsored by the New Mexico Brewers Guild itself. Those festivals often feature appearances by the characters who inhabit the breweries. There is also a solid group of beer geeks that travels from place to place, seeking out the latest releases and talking about it nonstop on social media.

One subject has always been figuring out how it seems as though every brewer is connected to at least one other brewer in his/her career. Over the course of assembling this book, it has also been fascinating to see how so much of the equipment, from brewhouses to fermenters, has moved about.

BREWER FAMILY TREE

A running joke in Albuquerque is that every brewer in town has gotten his/her start at Chama River, or Blue Corn Albuquerque before that. It is not exactly true, but it can be fun to trace where everyone came from in terms of getting their brewing start.

For many, Brad Kraus has earned the title of "Godfather of New Mexico Brewers." Kraus, a New Mexico native, had left the state in the 1980s to brew in Houston. He returned in 1990 to work for Santa Fe Brewing. "I

started in 1990 at Santa Fe Brewing Company out in Galisteo," Kraus said. "Had the original equipment from Boulder Beer Company. It moved out of the goat shed in Longmont to the horse barn in Galisteo. I worked for Ty's dad, Mike Levis."

Kraus was responsible for creating many of the beers that still feature in Santa Fe's regular lineup. "We did some great things out there," he said. "They were only making Santa Fe Pale Ale at the time. I developed several beers. I think the first one was a porter which we called Old Pojoaque Porter, and then Santa Fe Nut Brown Ale, and of course the original Chicken Killer Barley Wine."

The origin of Chicken Killer's name traces back to a Levis family pet. "There are so many stories about that dog, Petey, the little miniature dachshund. He was the Arnold Schwarzenegger of miniature dachshunds. They had Petey and Cocoa, who was this humongous chocolate lab. They had the run of this sixty-two acres out there, the little ranchito. He was just like so muscular, and he had a penchant for poultry," Kraus said. "Mike was like, 'That chicken-killing son of a bitch.' We're like, 'Well, we can't call a beer that.' We started thinking about it and thinking about it, and we'll call it Chicken Killer. He had killed all of Mike Levis's chickens, and then he went to the neighbors and killed all of theirs. We had reason to suspect that he killed two geese, and geese are mean. I don't know how the hell he did that."

Kraus left Santa Fe to start brewing at Rio Bravo in Albuquerque in 1993. He would go on to help found Wolf Canyon Brewery in Santa Fe in 1996, but it closed in 2000. Kraus was a consultant for years before a final stint brewing at Blue Corn from 2008 to 2011. He now lives and brews in Panama, making the occasional trip back to New Mexico.

Among the brewers Kraus trained over the years was Daniel Jaramillo at Rio Bravo. From there, Jaramillo went to Bavarian Lager Cellar, then Assets Grille and Brewery, then Blue Corn Santa Fe, then Marble and finally La Cumbre. Whether Jaramillo wants to hear it or not, he is now the veteran of the business, as Mark Matheson does not work on a daily basis at Kaktus. "I can't believe how much time has passed," Jaramillo said. "Here I am doing an interview with you about brewing. It's crazy."

Going brewery by brewery, the following is where every brewer has his/her origins, leaving out only those who came directly to Albuquerque from another state.

- Albuquerque Brewing: Head brewer John "Carnie" Bevz got his start under Ty Levis at Santa Fe Brewing.

Marble brewmaster Ted Rice (*right*) and brewer Daniel Jaramillo pose inside the brewery in 2008. *Courtesy of John Gozigian.*

- Boese Brothers: Sam Boese got his professional start working at Santa Fe Brewing.
- Bosque: John Bullard bounced around early in his career between Marble, where he worked with Ted Rice and Jaramillo; Chama River, where he worked with Jeff Erway; and Blue Corn, where he worked with Kraus. Bullard was the head brewer at Blue Corn before joining Bosque. Also on the Bosque staff now is Tim Woodward, who was an assistant brewer at Chama with Justin Hamilton and later served as head brewer at Turtle Mountain.
- Boxing Bear: Hamilton was previously the head brewer at Chama River. He was Erway's assistant brewer at Chama before taking over when Erway left to start La Cumbre.
- Canteen: Head brewer Zach Guilmette originally came to Il Vicino from Vermont. He served as an assistant brewer under Brady McKeown and then left to serve as head brewer at Chama River. Guilmette returned to Canteen as head brewer in 2015. Brewer Doug Cochran started at Kellys in 1996, assisting David Blackwell. When Blackwell left in 1999, Cochran spent a year as head brewer. He joined Il Vicino in 2000 and has been with the brewery ever

since, briefly serving as head brewer after McKeown left in 2015 to start Quarter Celtic, prior to Guilmette's return.

- Cazuela's: Brandon Venaglia was hired to replace Mike Campbell in 2014. Venaglia had previously worked at Back Alley Draft House, first as an assistant to Addison Poth and then as head brewer after Poth left for San Diego.

- Chama River: Current head brewer Andrew Krosche started his career at Marble, working with Ted Rice and Josh Trujillo. He left to become the second head brewer at Ponderosa in early 2015, only to jump to Chama when that position came open in the summer.

- Drafty Kilt: A forthcoming brewery in Albuquerque's Northeast Heights, Mike Campbell is the head brewer/owner. Campbell trained at Rio Grande and then succeeded Jaramillo as head brewer at Rio Bravo/Alvarado. After working as Kraus's assistant at Wolf Canyon in 1998, Campbell was the founding brewer at Tractor in 1999. He was then the founding brewer at Cazuela's in 2012.

- Kaktus: Matheson, who now serves more as a co-owner and is not involved in the day-to-day brewing operations, got his start as the first head brewer at Assets. He was then the founding brewer at Turtle Mountain from 1999 to 2014.

- La Cumbre: Jeff Erway founded the brewery after having worked at Chama River, first as an assistant to Rice and later as head brewer after Rice left to start Marble. Erway brought Jaramillo on board as head brewer, now director of brewing operations, in 2012.

- Marble: Rice, now brewmaster and president, started as an assistant brewer at Blue Corn Albuquerque, later becoming head brewer from 2000 to 2007. Current head brewer Josh Trujillo got his start at Marble, working his way up from sweeping the floor to packaging and assistant brewing.

- Nexus: Kaylynn McKnight worked as a hostess and server at Chama, where she met Erway. She later joined La Cumbre, becoming an assistant brewer under Erway and Jaramillo.

- Quarter Celtic: Brady McKeown started as an assistant brewer at the original Il Vicino location in 1994 before becoming head brewer in 1995. After a stint at the Il Vicino in Colorado Springs, he returned in 2000, running the show as Il Vicino moved to its current location and was renamed Canteen Brewhouse.

- Red Door: Brewmaster Wayne Martinez got his commercial start at Marble.

- Rio Bravo: Head brewer Ty Levis is the son of Santa Fe Brewing founder Mike Levis. He worked for many years at the brewery, even after his father sold his shares to current owner Brian Lock. Ty Levis parted ways with SFBC in 2014. John Seabrooks, the director of brewing operations, is the former head of research and development for Miller.
- Steel Bender Brewyard: The forthcoming brewery, which aims to open in Los Ranchos de Albuquerque, a small community in the North Valley, will have Robert Haggerty serving as head brewer. Haggerty, who learned at Oxbow Brewing in Maine, served as an assistant brewer at La Cumbre under Erway and Jaramillo. He later had a brief stint as head brewer at Ponderosa.
- Turtle Mountain: Current head brewer Mick Hahn started out at Marble, working for Rice and Trujillo.

As for the equipment, many of the pieces that make up each brewery can be traced back to another location. The original Bosque brewhouse is now in operation at Bathtub Row Brewing Co-op in Los Alamos. Canteen, then as Il Vicino, purchased the original Rio Bravo brewing system in the 1990s. That seven-barrel brewhouse was later sold to Rowley Farmhouse Ales in Santa Fe, which opened in late 2016. Canteen does still have at least one Rio Bravo fermenter still in use. La Cumbre's original brewhouse will be creating the beers at the forthcoming Drafty Kilt. Marble's original brewhouse is still in operation, albeit two states away at Smog City Brewing in Torrance, California. Nexus purchased the old Assets Grille brewhouse, which is still in use. Red Door's brewhouse was purchased from COOP Ale Works in Oklahoma City.

FORMATION OF NEW MEXICO BREWERS GUILD

The growth of the brewing scene meant more and more government regulation, necessitating some sort of collective approach to deal with the bigger issues facing the industry. The New Mexico Association of Small Brewers was founded in the 1990s, later changing its name to the New Mexico Brewers Guild. "I'm very proud of it," Kraus said. "I helped found, with Preston Cox, he and I founded what was at that time the New Mexico Association of Small Brewers, which eventually became the

New Mexico Brewers Guild. I was president for the first five years. I finally told them someone else had to take care of this. I can't do this all the time. I was really proud of what we did, and the legislative agenda since craft brewing was so young in New Mexico at that point, still. My biggest thing was that it took five years to do was I got the excise tax reduced from twenty-five cents a gallon to eight."

Kraus and the other brewery representatives later helped reinstate Sunday beer sales in New Mexico after the state legislature had briefly taken those away. Most importantly, they kept the breweries organized and speaking with a single voice. "We did a lot in those five years, and I feel proud of that," Kraus said. "These days [the guild has] done so much, it boggles the mind to see what they've done. I'm glad to see what it's grown into. Around the mid- to late '90s, we were up to around twenty-two breweries I think. Then, of course, the bubble burst at that point, and it went down a lot and slowly came back."

Gozigian, formerly of Marble, was named guild director in early 2015. "I had someone ask me the other day, 'What's the guild going to do over the next several years?' The answer is, there's not really an individual hot-button issue right now that we need to rally around necessarily that we know of, [but] I think there will be [eventually]," Gozigian said. "It's not a matter of if, it's a matter of when. The importance of the guild is to continue to maintain this ability to mobilize the craft brewers of New Mexico and their respective customer bases if we need to protect ourselves. There's always stuff going on in legislation that might not be on your radar, but it could be potentially detrimental to you. We have to protect ourselves. That's when we really show what we're made of."

GROWTH OF BEER MEDIA AND FAN SITES

The nascent craft beer scene in the 1990s received scant coverage from the *Albuquerque Journal* and other local newspapers. Typically, it was a mix of business stories about real estate purchases and the like or restaurant reviews for the brewpubs. It was not until the 2000s that more beer-centric writing would occur.

Local beer fan Patrick Cavanaugh started up a no-frills blog called *ABQ Beer Geek* around 2008. He always preferred to remain anonymous with the general public, but Cavanaugh became well known in the growing

community of his fellow beer geeks. He currently works as a "beertender" at Marble Brewery's downtown taproom. Cavanaugh was also instrumental in starting ABQ Beer Week, a series of craft beer–centric events held on an annual basis, usually in May.

The *ABQ Beer Geek* blog, in turn, inspired my friends and I to start up the NM Dark Side Brew Crew in 2012. A third website, ABQ Beer, joined the fray in 2014, offering up a map of breweries, beer reviews and more.

Social media became the primary point of communication for many in the craft beer community. Facebook group pages soon appeared, such as "New Mexico Let's Talk Craft Beer" and "New Mexico Craft Beer Enthusiasts," offering up platforms for discussion and promotion. Twitter and Instagram also became hotbeds of beer discussion. Local beer fan Karim Fattah earned a following with his amazing photographs of local beers posted to social media, all the more amazing considering he had no formal training in photography and was usually just using his cellphone to take the pictures. He would be just one of dozens of everyday beer geeks to earn such a following.

Of course, chatting online about beer is one thing, but gathering in person to actually drink it is the primary goal of beer lovers. The ABQ Craft Beer Drinkers Group has long been organizing beer-drinking outings, bringing together longtime residents and newcomers to the Duke City. Monica Mondragon, who now runs the laboratory at Santa Fe Brewing, and Adam Auden, who is in charge of all the beer at Jubilation Beer Wine and Spirits, have served as the primary organizers for the group.

More mainstream media outlets also began to offer up regular coverage of the breweries, festivals and other craft beer news. The *Albuquerque Journal*'s Jessica Dyer handled the business of beer, while Rozanna Martinez's Friday columns in the Venue entertainment section typically highlighted local craft beer events. *Albuquerque Business First* also offered up regular craft beer coverage, including a Battle of the Breweries online competition in 2016. Boxing Bear, fresh off its wins at the Great American Beer Festival, was the winner in what was promised to be an inaugural competition. The three local television stations also offered up craft beer news on their nighttime broadcasts, with KOAT Channel 7 (ABC) frequently dropping in on La Cumbre, which was only a mile or so from its newsroom.

GROWTH OF HOPFEST, BLUES & BREWS, NM BREWFEST AND MORE

The first beer festivals in New Mexico began to pop up in the 1990s and early 2000s. Any available space was used, even brewery parking lots from time to time. Assets' parking lot was home to a festival more than once, with customers treated to unlimited sampling and the breweries hanging out for hours on end, often into the late hours of the night.

An advertisement for the first Brewers' Festival was posted to the *Journal* in 1997. The event was held on September 21 at Century Plaza, near the intersection of Cerrillos and Rodeo, where the main Blue Corn Brewery had just been built. Breweries would do whatever they could to generate interest from a general public that had yet to truly embrace craft beer. "The culture was very much…some people were shocked that I could make this," Mike Campbell said. "Just getting people to taste it for their first time [was difficult]. Any festival, any chance I could get to take a keg and get someone to taste it inside the restaurants, anywhere I could go. Now I feel like some of these people's parents, their kids are the ones drinking the craft beer now."

Marble later had its own festival, Septemberfest, which was held in the back parking lot for years. It was the first festival I ever attended in New Mexico, earning me quite the sunburn back in 2010. The ongoing construction projects around the brewery pushed it out onto Marble Avenue in 2014, before it was finally canceled in 2015.

Currently, there are three major festivals that have managed to survive for years in the Albuquerque area, all in the warmer months between May and October.

Blues & Brews and Hopfest bookend the summer, with the former usually taking place in May as part of ABQ Beer Week, while the latter has usually been held in August. Both are organized by Feel Good Festivals, a nonprofit under the direction of Marne Gaston.

Blues & Brews has been held every year at the Sandia Casino just north of Albuquerque, save for one year at the Isleta Pavilion south of town in 2013. Hopfest has recently been held at the Isleta Casino south of Albuquerque. Any festival held on a Native American reservation is not subject to oversight by the State of New Mexico's Special Investigations Division of Alcohol and Gaming, which has often been restrictive toward the concept of unlimited sampling. Hopfest's origins had come in a couple of parking lots. "That was a huge jump up, and we learned a lot about the [liquor] laws in New Mexico," Gaston said. "They were a lot more lenient

with us when we were smaller. When we got bigger, the city was not going to let us get away with anything. So, we found that to be complicated. I got an e-mail from Hard Rock [now Isleta] Casino saying they wanted me to create a beer festival for them."

ABQ Beer Week was launched in 2011 as a means of promoting local breweries and beer bars and to increase public awareness of craft beer, both local and from outside the state. Gaston and Cavanaugh were the co-founders of the series of events, which now stretches out far more than just seven days, usually in May, with Blues & Brews as the signature event.

One of the newer additions to Beer Week is the 505 Collaboration beer, with multiple brewers joining forces to create a special beer that is then offered up at as many local breweries wish to serve it.

The New Mexico Brew Fest is usually the final major festival of the season. Held for the past seven years at Expo New Mexico, the home of the state fair in the heart of Albuquerque, it has more of an Oktoberfest theme, usually featuring only New Mexico breweries.

Other popular festivals include the various events held throughout the year at Pajarito Mountain above Los Alamos, the WinterBrew festival in Santa Fe every January and, of course, the New Mexico IPA Challenge, held at multiple breweries around the state every July.

The Future

In the final weeks I spent finishing this book, the craft beer scene in Albuquerque continued to fluctuate. Dialogue Brewing had opened back in September, while The 377 Brewery surprisingly opened in late October. Palmer Brewery and Ciderhouse, which had seemingly been in limbo for ages as a part of Left Turn Distilling, held its grand opening on November 5. The Firkin Brewhouse announced that same weekend that it was closing its doors for good.

Signage went up on Central Avenue in Nob Hill announcing that the long-delayed Hops Brewery was about to open. Construction continued on the Steel Bender Brewyard in the North Valley suburb of Los Ranchos de Albuquerque. The Bombs Away Beer Company applied for a small brewer license with the State of New Mexico, looking to open near the affluent Four Hills neighborhood in the Southeast Heights.

Needless to say, the industry is continuing to evolve. "The brewing industry in 2016…we just look back and laugh at what it was like back in the day," Nico Ortiz said.

As more and more breweries have opened, it has certainly created a new scene for the brewers themselves. "There was a sense of us against them, it was us, the brewers, against the [macro] beer drinkers," Doug Cochran said. "I think that really helped this industry get to the point of where it's at now. I think it's changed now. There are still some old-school veterans; I think we all look out for each other. Some of the new guys, I don't think that they want to cut into the market, and I don't know the integrity of these

people opening a brewery. It's one of the coolest things out there, but just because you spent a lot of money, it's not a guarantee you're going to make something that's worthwhile. You can spend $5 million like Rio Bravo did, but it's not a guarantee your quality is going to be up there."

It is that struggle, keeping as much of the beer at a high level of quality as possible, that figures to occupy many of the breweries and the Brewers Guild. "What's scary is people look at making beer as easy, because of what the professionals do," Cochran added. "The main heavy hitters in this town, as long as we've been around doing it so consistently, they think they can push a button and beer will come out. They don't understand how much we sweat, how much we worry about it. It's literally a labor of love and hate in some ways."

Firkin, which opened without an experienced brewer, was a good example of that. In fact, save for the Stumbling Steer, almost every recent brewery to close employed a head brewer who had no prior commercial experience. Some of the new breweries have acknowledged this, with Dialogue hiring Ian Graham from Greenport Harbor Brewing in New York and Steel Bender already hiring Bob Haggerty, a former head brewer at Ponderosa and assistant brewer at La Cumbre.

For the most part, a number of local brewers and brewery owners have said that they expect a sort of "weeding out" period, where the strongest breweries will survive, while their smaller, or even over-capitalized, brethren shut their doors. Still, even as craft beer's meteoric growth slowed in 2016, the continued development of the overall industry was apparent in New Mexico and beyond.

"I toured a new hop farm [recently] called Tributary," Ted Rice said. "Tributary is owned by the Smith family. They've been farming since 1930. The Smith family own all these ranches and also farms dedicated to a brewery. These folks have been in business a long time. This new harvesting and farming facility, it used to be an orchard site. Now they're growing Simcoe, Citra, Mosaic, Equinox and more hops. They told me if you told me four years ago that I would be doing this, clearing land for hops, I wouldn't have believed you."

For now, Rice said, relations are good between all the components of the craft beer industry. Whether it will stay that way remains to be seen. "There's a strong partnership between brewers, growers and distributors," he said. "I'm pleasantly surprised by the direction but cautious at the same time….Everyone is still doing well. New Mexico is not a highly populated state, so how many breweries can it sustain? What

Marble Brewery completed its massive expansion project early in 2016. *Mario Caldwell.*

percentage of the population here are craft beer consumers? Based on history and analyzing the markets, we're still learning."

The future of craft brewing in Albuquerque figures to include some continued expansion of existing breweries. Marble completed a massive expansion downtown in early 2016. La Cumbre had expanded the prior year. Bosque was working on a production facility located in Bernalillo, having maxed out almost all available space in its strip mall location on San Mateo Boulevard. Boxing Bear was increasing its space as well, and that was before it won multiple awards at the 2016 Great American Beer Festival.

As for the future additions of new breweries, two patterns could soon emerge. First could be geographic, with breweries seeking to open in areas that are currently empty of taprooms. A map of Albuquerque still shows that breweries in town are clustered in certain areas, around downtown, Nob Hill, the Interstate 25 corridor and so on. Much of the populous west side is devoid of local craft, while a good portion of the Northeast Heights remains empty as well. Part of the Heights problem is a combination of high rent on certain major streets, such as Tramway and Paseo del Norte, or the effects of cross-zoning between commercial and residential areas that are designed to discourage establishments that would serve or produce any type of liquor. Poorer areas of town—such as the South Valley, Southwest Mesa and Southeast Heights—are likewise without breweries of their own.

A second possibility would see the establishment of specialized breweries. Duel Brewing in Santa Fe, which opened a taproom in downtown Albuquerque, almost exclusively brews Belgian-style beers. Dialogue likewise specializes in European styles, with a heavy Belgian and German influence in the beers it has created so far. Denver, a city with one hundred breweries and counting, has already seen the arrivals of these types of specialized breweries, from ones that focus on sour and wild ales

(Crooked Stave) to German beers (Prost), to even breweries that go heavily thematic, such as TRVE and Black Sky, both of which are deeply steeped in heavy metal music imagery and sound. New brewpubs could push for an even greater symbiosis between the kitchen and brewery, leading to menus focused on unique food/beer pairings. More combined brewery/ distillery operations, similar to Broken Trail and Left Turn/Palmer, could also eventually be in the works.

Of course, the future is not without its challenges. A group called Alcohol Taxes Save Lives & Money was pushing for a hefty new tax to, at least in part, help solve the State of New Mexico's sizable budget deficit. Others believe that the tax would be an attempt to curb alcohol sales and production in an effort to reduce the number of drunk driving arrests and accidents, as New Mexico has some of the highest per capita rates of DWIs in the country. La Cumbre's Jeff Erway called it a "neo-prohibitionist" stance.

"Despite what MADD [Mothers Against Drunk Driving] would have you believe, this is simply a neo-prohibitionist proposal that is aimed at limiting people's access to alcohol, and it will hurt the State's breweries, wineries and distilleries most by making their products more expensive to the end consumer. You will take a local product that is viewed as an affordable luxury and make it unaffordable to our already cash strapped residents," Erway said in a letter to the editor shared on the Dark Side Brew Crew website. "Instead of supporting local businesses, the consumer will be economically forced to support the very largest of producers who can afford to keep their prices and margins at rock bottom. As has been shown time and time again, this will not change the consumption of the heaviest drinkers, just which alcohol is purchased and therefore where that alcohol was produced. According to a study by Willard Manning et al. in 1995, moderate drinkers are far and away the most guided by the price of alcohol and will simply choose to not drink when prices become absorbent."

Many brewers have stated that they would be forced to close up shop should customers be unwilling to endure a significant increase in prices; others have said that they would move their entire brewing operation out of the state. The proposed tax increase was expected to be part of the January 2017 legislative session, although Republican governor Susana Martinez was expected to veto any new taxes, particularly ones that could actually cost people their jobs.

Even on a national level, people in the industry are monitoring the situation in New Mexico. As BA president Bob Pease said during GABF:

The Brewers Association is aware of what is happening. That is why, for the last ten years, we have encouraged and helped in the formation and strengthening state guilds in all fifty states. Now there is a strong state guild in New Mexico and many other states. The next step we have been working on is to make sure that every state has a paid, full-time executive director. To ensure this, we have allotted up to $500,000 in grants to state guilds to hire and pay the best people to represent these guilds. We will then do everything in our power to help those state guilds activate and create a strong support base when it comes to helping them in situations such as the one New Mexico is facing. Working with the state guild in New Mexico and the American Homebrewers Association, we need to make sure people understand that any such proposal would be a job-killing proposal that would not create revenue. Not many legislators these days want to be seen as job killers. We have to make sure politicians are aware of this in our fight to prevent it from happening.

Whatever happens with the proposed tax, it does show that even with prosperity, there are new challenges for the breweries in Albuquerque and the rest of New Mexico. The future is certainly bright, much brighter than it has ever been in local history, but there will still be ups and downs to come. It will be a fascinating thing to continue to follow, something I plan to do on nmdarksidebrewcrew.com and, of course, in person at the many taprooms around town. A beer writer's work is never done.

Cheers!

Selected Bibliography

Interviews

Mike Campbell (brewer) in discussion with the author, September 2016.
Mike Carver (retired brewer) in discussion with the author, September 2016.
Doug Cochran (brewer) in discussion with the author, September 2016.
John Gozigian (director of New Mexico Brewers Guild) in discussion with the author, September 2016.
Daniel Jaramillo (brewer) in discussion with the author, June 2016.
Brad Kraus (retired brewer) in discussion with the author, September 2016.
Mark Matheson (brewer) in discussion with the author, September 2016.
Brady McKeown (brewery) in discussion with the author, August 2016.
Nico Ortiz (brewery owner) in discussion with the author, August 2016.
Ted Rice (brewery president) in discussion with the author, September 2016.
Rich Weber (brewery owner) in discussion with the author, September 2016.

Sources

Albuquerque, New Mexico City Records, 1934–39.
Albuquerque Journal Archives, 1905–2005.
Albuquerque Tribune Archives, June 28, 1971.
New Mexico Dark Side Brew Archives, 2012–16.
Stott, Jon C. *New Mexico Beer: A History of Brewing in the Land of Enchantment.* Charleston, SC: The History Press, 2014.

Index

A

ABQ Beer Week 115, 116, 117
ABQ Brew Pub 60
Albuquerque Brewing 15, 18, 19, 77,
 93, 110
Ale Republic 98, 99
Alien Brew Pub 60
Alvarado Restaurant and Brewery 35
Apers, Peter 97
Assets Grille and Brewery 19, 20, 21,
 22, 23, 25, 28, 36, 40, 44, 45,
 89, 94, 96, 110, 112, 113, 116

B

Bad Ass Brewery 54
Baker, Randy 79
Bavarian Lager Cellar 34, 35, 36, 41,
 67, 104, 110
Berry, Dan 74, 75
Bevz, John "Carnie" 77, 110
Bistronomy B2B 72
Blackwell, David 31, 111
Blue Corn Brewery 37, 38, 39, 40, 41,
 43, 45, 49, 50, 51, 52, 69, 101,
 103, 104, 106, 107, 109, 110,
 111, 112, 116

Blue Grasshopper Brew Pub 97
Blues & Brews 81, 116, 117
Boese Brothers Brewery 78, 79
Boese, George 79
Boese, Sam 111
Bonfantaine, Dennis 30, 31, 36
Bosque Brewing 68, 70, 71, 72, 76,
 84, 91, 102, 103, 104, 106, 107,
 111, 113, 120
Boxing Bear Brewing 56, 74, 82, 102,
 104, 107, 111, 115, 120
Broken Bottle Brewery 55, 56, 57, 72
Broken Trail Brewery and Distillery
 78, 121
Buckner, Mike 18, 19, 93, 94
Bullard, John 69, 70, 71, 102, 106,
 107, 111

C

Cabezon Brewing 28, 30, 45, 47, 50,
 52, 88
Campbell, Mike 35, 92, 96, 112, 116
Canteen Brewhouse 64, 74, 82, 84,
 104, 107, 111, 112, 113
Carson, Ken 64, 65, 66
Carver, Mike 28, 30, 45, 47, 50, 88
Cavanaugh, Patrick 114, 115, 117

Cazuela's Mexican Grill and Brewery
96, 97, 104, 112
Chama River Brewing 41, 43
Chavez, Chris 55, 56, 57
Chavez, Rob 23, 24
Cochran, Doug 31, 33, 36, 37, 40, 44,
63, 111, 118

D

Davis, Kevin 73, 75
Devore, Skye 61, 62, 93
Dialogue Brewing 83, 118, 119, 120
Dry Gulch Brewing and Grill 41, 67
Duel Brewing 84, 120
Dunagan, Andy 34, 36

E

Erway, Jeff 57, 58, 59, 66, 69, 101, 104,
107, 111, 112, 113, 121

F

Firkin Brewhouse 81, 118, 119

G

Gaston, Marne 116, 117
Gozigian, John 38, 39, 43, 44, 48, 49,
51, 52, 114
Great American Beer Festival 58, 69,
71, 74, 100, 107, 115, 120
Guilmette, Zach 102, 111, 112

H

Haggerty, Robert 76, 113, 119
Hahn, Mick 91, 113
Hallenbrick Brewing 54
Hamilton, Justin 74, 82, 101, 103, 105,
107, 111
Hargis, David 61, 93
Hart, Tom 25, 35, 47, 88
Hennessy, Tom 23, 25
Holder, Allen 88
Hopfest 116

I

Il Vicino 23, 24, 25, 27, 28, 31, 32, 36,
40, 44, 48, 51, 61, 63, 64, 82,
89, 96, 101, 102, 103, 104, 106,
111, 112, 113

J

Jaramillo, Daniel 27, 34, 35, 36, 45,
50, 58, 59, 66, 69, 105, 110,
112, 113
Jensen, Gabe 68, 71
Jinnett, Jeff 38, 39, 41, 43, 44, 48, 50

K

Kaktus Brewing 84, 94, 96, 110
Kellys Brew Pub 30, 32, 36, 37, 40, 44,
48, 61, 72
Koller, Dana 94, 95
Kraus, Brad 22, 23, 27, 33, 50, 69, 89,
92, 109, 113
Krosche, Andrew 76, 112

L

La Cumbre Brewing 27, 57, 58, 59, 61,
63, 64, 66, 76, 77, 81, 84, 86,
101, 103, 104, 107, 110, 111,
112, 113, 115, 119, 120, 121
Lane, Donavan 55, 56
Levis, Mike 18, 22, 79, 110, 113
Levis, Ty 79, 110, 113
Lizard Tail Brewing 55, 74
Loeb, Henry 12, 13
Loeb, Jacob 12
Logan, Larry 94

M

Maase, Steve 88
Manzano Mountain Brewing 88, 99
Marble Brewery 48, 64, 91, 115
Martinez, Wayne 76, 112
Matheson, Mark 20, 21, 23, 36, 57, 89,
91, 94, 95, 110, 112

McKeown, Brady 24, 25, 27, 40, 63, 82, 89, 101, 111, 112
McKnight, Kaylynn 66, 112
Michnovicz, Jotham 68, 70, 108
Milagro Brewing 93, 94
Moore, Scott 25, 35, 47, 48

N

National IPA Challenge 71, 107
New Mexico Brewers Guild 109, 113
New Mexico Brew Fest 117
New Mexico Brewing 16
New Mexico IPA Challenge 54, 69, 71, 74, 100, 105, 117
Nexus Brewery 64, 66, 84, 102, 104, 112

O

Ortiz, Nico 33, 36, 41, 47, 53, 57, 88, 89, 90, 91, 94, 106, 118

P

Palmer Brewery 118, 121
Pi Brewing 73
Pluemer, Herb 92
Ponderosa Brewing 75, 76, 112, 113, 119

Q

Quarter Celtic Brewpub 82

R

Rankin, Don J. 12
Rankin, Harry 12
Red Door Brewing 76, 77, 84, 112, 113
Rice, Ted 39, 41, 42, 43, 44, 48, 50, 52, 57, 59, 69, 102, 104, 111, 112, 113, 119
Richards, David 22, 35
Rio Bravo Brewing 22, 23, 25, 27, 28, 32, 33, 34, 35, 40, 78, 79, 80, 89, 110, 112, 113, 119
Rio Grande Brewing 17, 21, 25, 26, 28, 30, 35, 40, 44, 47, 48, 52,

53, 55, 60, 72, 74, 88, 92, 101, 112
Ruth, Guy 32, 41, 88

S

Salgado, Eliot 83
San Ysidro Brewhouse 32, 33, 36, 41, 78, 88
Schulz, O.S. 16
Sidetrack Brewing 81
Sierra Blanca Brewing 25, 35, 36, 45, 47, 48, 60, 68, 101
Simonds, Matt 78
Smith, Frank 22, 35
Smith, Lisa 22, 35
Southwestern Brewery and Ice Company 12, 13
Starr Brothers Brewing 81
Steel Bender Brewyard 76, 113, 118, 119
Stumbling Steer, the 67, 75, 119

T

377 Brewing, The 118
Tractor Brewing 48, 61, 62, 63, 92, 93, 96, 112
Turtle Mountain Brewing 33, 36, 41, 48, 53, 57, 88, 89, 90, 91, 94, 97, 106, 111, 112, 113

V

Venaglia, Brandon 97, 112
Villareal, Greg 73
Volcano Brewery 36, 88
Von Gontard, Paul 17

W

Weber, Rich 25, 35, 47, 60
Westwind Brewing 93
Woodward, Tim 91, 111
World Beer Cup 35, 42, 71, 74, 96, 100, 104

About the Author

Chris Jackson is a writer, beer lover, sports fanatic and metalhead living in his hometown of Albuquerque. A graduate of the University of Arizona, he applied his writing skills as a sportswriter and copy editor at the *Arizona Daily Star* in Tucson and later at the *Daily Breeze* in Torrance, California. After moving home in 2008, he has worked as a freelance writer for the *Albuquerque Journal*, the *Sports Xchange*, MiLB.com, *Lindy's Magazine* and more. Jackson also found himself spending much of his free time enjoying the local craft brewing scene. Together with friends, he founded in 2012 the NM Dark Side Brew Crew, an online writing collective of beer-loving writers, chronicling the explosive growth of the breweries in Albuquerque and the surrounding area.